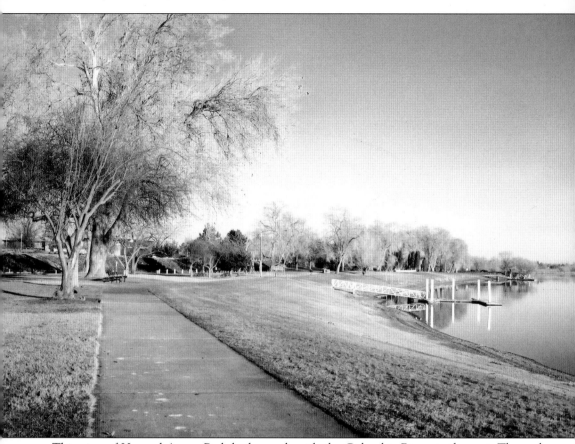
This view of Howard Amon Park looks north with the Columbia River to the east. The park was originally named Riverside Park. In 1968 the park was renamed after Howard Amon, the man who platted the original Richland in 1906 and donated the land for the park in 1911.

Elizabeth Gibson

Copyright © 2002 by Elizabeth Gibson.
ISBN 0-7385-2061-6

First Printed 2002.
Reprinted 2003.

Published by Arcadia Publishing,
an imprint of Tempus Publishing, Inc.
Charleston SC, Chicago, Portsmouth NH,
San Francisco

Printed in Great Britain.

Library of Congress Catalog Card Number: 2002104382

For all general information contact Arcadia Publishing at:
Telephone 843-853-2070
Fax 843-853-0044
E-Mail sales@arcadiapublishing.com
For customer service and orders:
Toll-Free 1-888-313-2665

Visit us on the internet at http://www.arcadiapublishing.com

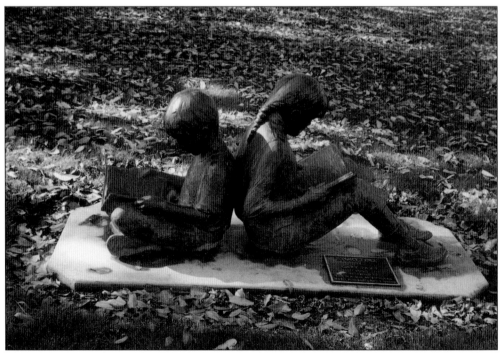

This sculpture of a boy and girl reading was installed at John Dam Plaza across from the Federal Building in 1993. *Storytime* was crafted by Gary Price. Depicting the joy of reading, the sculpture was dedicated to the families of Richland by HAPO Federal Credit Union.

Contents

Acknowledgments 6

Introduction 7

1. Before the Government Came 9

2. The War Years 17

3. The Post-War Years 47

4. Richland Becomes a City 85

5. The Pride of Richland 91

ACKNOWLEDGMENTS

Patti Jones Ahrens
71A, 75A, 75B, 79B, 80A

Dennis Armstrong
31, 34B, 35A, 58B, 59A, 62A

Paul Beardsley
10A, 11B, 13B, 14B, 16A, 19A,
22A, 22B, 23B, 24A, 30B, 36B,
38A, 45B, 58A, 86B, 87A, 87B,
89A, 90B, 96B, 99B

Christ the King
Catholic Church
19A, 34A, 83A, 83B, 108A, 109B,
123A, 123B

City of Richland
86A

Columbia River Exhibition
of History, Science and
Technology
9, 17, 18, 21, 27A, 28, 60

Columbian Yearbook,
Richland High School
52B, 53A, 62B, 63B, 71B, 72A, 81,
79A, 82, 84B, 93A–96A, 105–106B,
107B

East Benton County
Historical Society
10B, 11A, 12A, 49, 88A, 90A

Energy Northwest
108A

Elizabeth Gibson
2, 4, 20A, 27B, 32A, 33B, 38B, 48B,
50–52A, 53B, 54A, 56A, 56B, 61B,
84A, 89B, 91, 92A, 98B,
111A–113A, 118A, 121B, 122A,
122B, 125A–128

Gyre Yearbook, Hanford
High School
101A–104A

Hanford Photography
88B, 92B, 97, 100B, 107A, 116A,
116B

Carol Hutchison
48A, 57A, 57B, 76A

Lucille Mattis
98A

Mary McDonald
99A

Pacific Northwest National
Laboratories
115B, 124B

R2K Reunion Committee
118B–121A

Jimmie Shipman
29A, 35B, 42B, 47B, 59B

Hal and Pook Smith
16B, 20B, 25A–26B, 29B, 30A,
32B, 33A, 39A–42A, 54B–55B,
63A, 64–70A, 72B–74B, 76B, 78,
79A, 85

Donna Thompson
80A

John Vann
113B, 115A

Marie White
12B, 13A, 14A, 15A, 15B, 24A,
36A

Jack Young
37, 46A, 46B

Jim Young
23A, 43, 44, 45A, 61A, 70B, 104B,
109B, 110A, 110B, 114A, 114B,
117A, 117B, 124A, 128

Introduction

Benton County in southeast Washington State had long been used by Native Americans as a fishing and camping site. The Yakima River delta was an especially popular early camp site. The first white settler in Richland was John B. Nelson, who built a cabin near the mouth of the Yakima in 1863. By the 1880s, several other families had settled in the area and irrigated crops. Though the potential was high, lack of irrigated fields kept the population relatively small.

In 1905, the first post office was opened for the town of Benton. A few months later after a naming contest was held the name was changed to Richland. From that point, the town grew slowly, reaching a population of just 240 by 1943. Residents made a living mainly by growing and selling agricultural products.

But then everything changed. America declared war on Japan after the December 7, 1941 bombing of Pearl Harbor. A year later, it looked as if war could drag on indefinitely. Politicians and scientists began to look for a way to end it quickly. In December 1942, a nuclear chain reaction was sustained for the first time at the University of Chicago's Metallurgical Laboratory. After that, the federal government moved rapidly toward building the world's first atomic bomb. Major General Leslie A. Groves was appointed Commander in Chief of the Manhattan Project, named for the Manhattan District of the Army Corps of Engineers. The Manhattan Project would consist of three top-secret locations in Washington State, New Mexico, and Tennessee.

In December of 1942, Major General Groves and Colonel Franklin T. Matthias scouted the locations to build the bomb factories. The two men declared this site in eastern Washington as the perfect location for the manufacture of plutonium. The remote location, a reliable water supply, a solid basalt foundation for building, abundant and cheap electricity from the Grand Coulee and Bonneville Dams, and a low threat from natural disasters contributed to the selection of central Benton County as the location for the secret government project. Colonel Matthias was appointed the officer in charge of Site "W" in Washington.

Before construction could begin, the current residents of the three small towns of Richland, Hanford, and White Bluffs had to be relocated. In March of 1943, the government condemned their property. Most residents had to leave immediately, though a few were allowed to bring in their final harvests. At the old townsite, a construction camp was quickly erected to house the workers that would build the bomb-making plants.

The site, called Hanford Engineer Works, took its name from one of the towns that was evacuated. The camp that housed the site workers looked like a typical military camp with barracks and Quonset huts. The camp also supplied everything the workers could possibly need,

including schools, recreation halls, and stores. At peak production time, the camp housed 51,000 people. The part of Richland near the Yakima River delta remained and experienced a building boom of its own, driven by a need to support the construction camp.

When construction on the first reactor began in March of 1943, the army and DuPont, the prime contractor, strove to meet plutonium production goals. Between March of 1943 and August of 1945, the Manhattan Engineers District would build over 500 major and minor buildings on the Hanford Site. Construction on the B Reactor began in August of 1943 and was the first nuclear facility to come on line in September of 1944. D Reactor and F Reactor were also producing plutonium by December 1944. By July of 1945, the three reactors had produced enough plutonium to test an atomic bomb. On July 16, such a bomb was tested with Hanford plutonium in Alamogordo, New Mexico, at a site later known as Trinity.

The bomb dropped on Nagasaki on August 9, 1945, contained the plutonium manufactured at Hanford. A few days later, when Japan surrendered, the local paper finally revealed just what was going on at the Hanford area. Rumors had said it was everything from campaign buttons to toilet paper! Except for a few top-level scientists and army personnel, no one had known what they were working on, only that their efforts were important to the war effort. Residents and the nation were astounded at what they had accomplished. Though the bomb would later be surrounded in controversy, in 1945 it was thought to be the most expedient method to end the war for good. By halting the continuation of the war, it saved thousands of possible deaths on all sides if the war had continued. It also established the United States as a dominant world power.

After the war was over residents expected that Richland would go back to being a sleepy little town. But it would not happen that way. Research on atomic energy, radioactive elements, and other uses for nuclear physics kept the town booming through the Cold War years. Richland was operated like a company town, and the company was the federal government. All the homes and business were owned by the government. If home repairs were needed, the government supplied the materials and labor. The residents felt like one big family, proven when all hands had to pull together during the big flood of 1948.

In December of 1948, the former town of Richland was legally disincorporated. Even so, it was estimated that Richland was the tenth most populous city in the state, with approximately 24,420 people. Richland had grown by a hundred-fold in just six short years. Many of those who came would never leave, and second and third generations of families would give their lives to the Hanford project. The city added many more new businesses, schools, and churches. Some of the businesses begun during those post-war years are still operating today; many other buildings still stand, though other businesses occupy the space.

It wasn't until 1958 that the government relinquished control of the city. Richland was reincorporated and city officers were elected. The town continued to grow, financed by large government contracts. Richland became the site of many state-of-the-art laboratories and research centers throughout the 1960s and 1970s.

When the Cold War ended in 1992, the role of the Hanford project changed from one of defense to one of environmental cleanup. Several decades of nuclear research and development have resulted in various forms of hazardous nuclear waste that have to be stabilized and safely stored. Once again, Richland residents have risen to the challenge.

One
BEFORE THE GOVERNMENT CAME

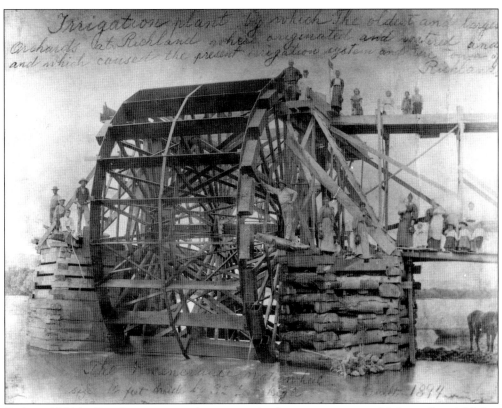

Built in 1894 by Ben Rosencrance, this water wheel was enormous, at 32 feet tall and 16 feet wide. It dispensed 320 gallons over the desert with each rotation. The wheel churned the waters of the Yakima River near today's Interstate 82 bridge in Richland. The wheel had enough capacity to water the orchards and fields north of the Yakima River, as far north as present day Williams Boulevard.

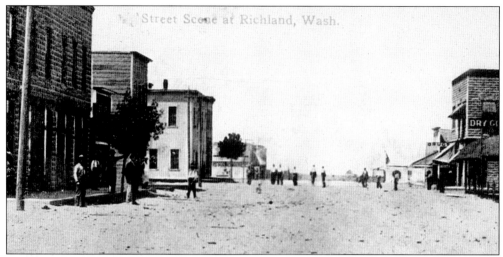

In 1910, downtown Richland didn't look much different from a frontier town in the wild, wild west. This view looks north on George Washington Way, then called Columbia Avenue, where Lee Boulevard would later intersect. The two-story building on the right is the Amon Building, which housed the Richland bank. The light-colored two-story building on the left is the Richland Hotel and Summers Restaurant. Beyond it is Michener's Hardware.

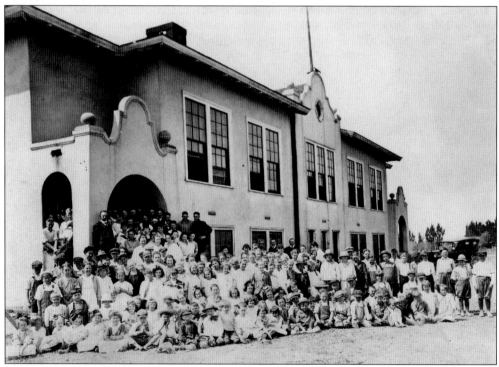

Construction on Richland's first high school began in 1911. It was located at Jadwin (then Goethals) and Downing. A.V. McReynolds won the contract to build the school. The building was made of concrete and had a complete basement. The building cost of $21,490 included heating and plumbing. The building was dedicated in 1912. This picture was taken in 1918, and all of the school's students and teachers were in attendance.

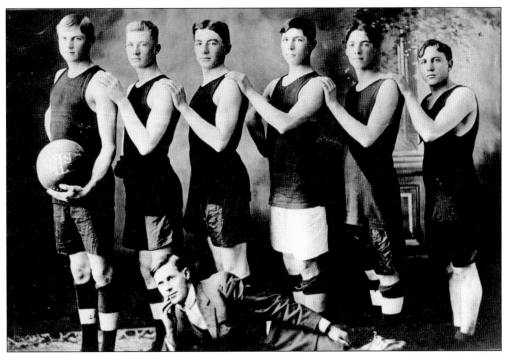

Richland High School started its tradition of fine basketball teams as far back as 1911. Standing, from left to right, are Walter Timmerman, Clarence Yedica, Arnold Burmaster, Eugene Mitchell, Carroll Harding, and Phil Schireman. Lying down is coach M.B. Clark. Also on the team, but absent from the photo, was Paul Granlund.

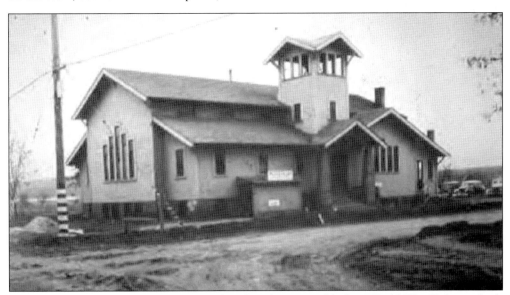

The Methodist Church was one of two churches that existed before World War II. It was built in 1912 where the current Southside United Protestant Church stands on Jadwin and Comstock. At that time the streets were named Second and Dudley. During the war, the building was used for offices. Redeemer Lutheran used the building after the war until 1951. Following their use, it was torn down.

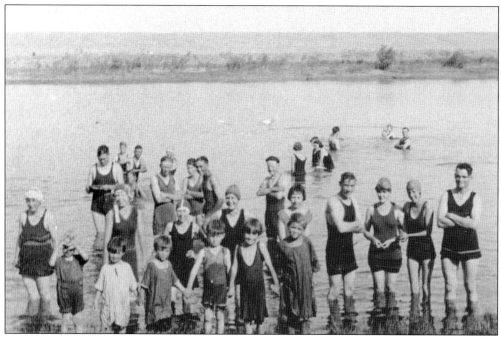

The swimming hole at Nelson's Lake was a slack spot between Nelson's Island and the west bank of the Columbia River. The island is near the end of present-day Newcomer Street. This picture was taken in 1923. The first row of adults are identified, left to right, as Mrs. Harrington, Alice Lindskog, Madeline Wiesenbach, Gladys Hackney, Myrtle Barnett, Garnett Meredith (behind Myrtle), Earl Jones, Lucille Harmon, Dorothea Martin, and Everett Jones.

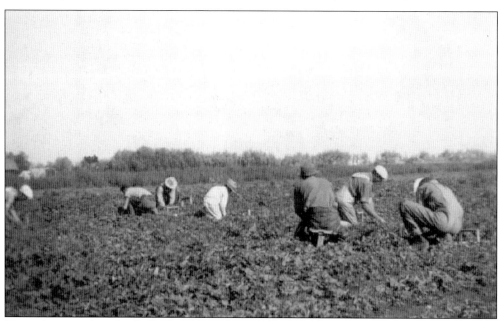

The volcanic soil in the Columbia Basin was very fertile and supported a variety of crops. This strawberry field north of Richland was harvested by the Hanson family in the 1930s. They also grew potatoes and peppermint.

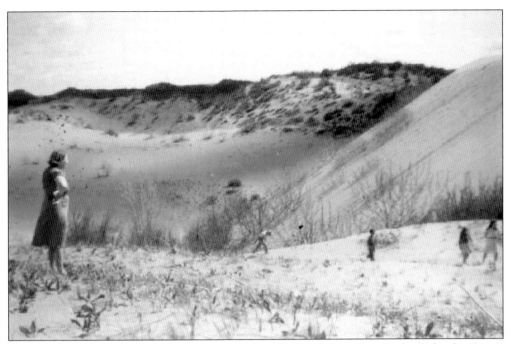

In the early days, as now, sand dunes cover much of the basalt lava flows in the Columbia Basin. Bunch grasses and wildflowers anchored the sand from blowing in huge dust clouds. This family enjoys a leisure day of playing outdoors. Some dunes were piled quite high and could be slid down just like a snowy hill.

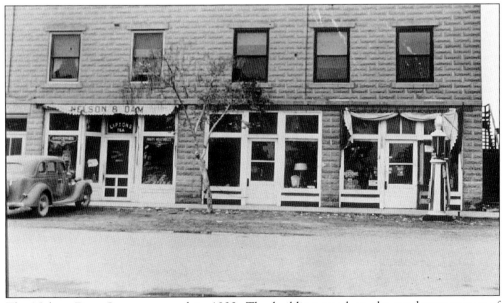

The Nelson-Dam Grocery opened in 1932. The building stood on the southwest corner of George Washington Way and Lee Boulevard. The building originally was built in 1906, with bricks manufactured at a concrete block factory that stood to the southeast. At one time, the gas pump at this store was the only one in town. Today Zinn Photography and Carlson-Wagonlit Travel occupy this space.

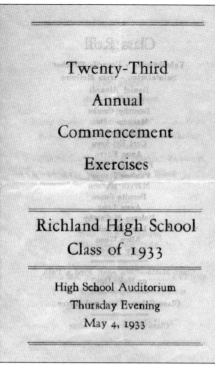

Graduation at Richland High School took place on May 4, 1933. It was the 23rd graduating class since the high school opened. This very small pamphlet is a small remembrance of the ceremony. There were just 16 graduates. The class motto was "We Shall Find a Path or Make One."

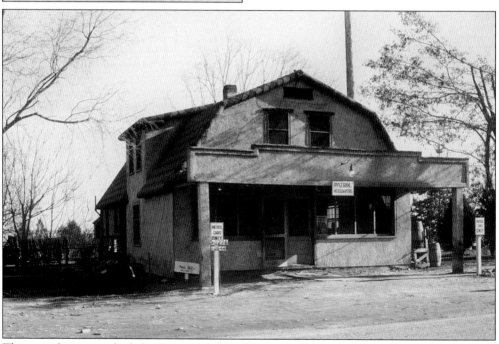

This tract house was built by George McClendon in 1935. The house was located on the east side of George Washington Way, just north of Lee Boulevard. When the government came, the home was appropriated for use as the Hanford Patrol Headquarters. A number of businesses occupied the building after it was vacated by the government. The area where the building once stood is now part of a parking lot.

```
DEPARTMENT OF JUSTICE, LANDS DIVISION
         309 Empire State Bldg.
         Spokane, Washington

               March 5 , 1943

Dear Sir or Madam:

         Re:  U. S. vs. Alberts, No. 128

         You are advised that on February 23, 1943 the United States
of America instituted the above proceeding to acquire certain real prop-
erty by condemnation, including lands apparently owned or occupied by
you.  Pursuant to the court order that day entered in said proceeding
I herewith enclose a copy of such order, which will serve to advise
you that the United States was on said date given the right immediately
to take possession of such property.

         By a subsequent order it was directed that the copy need not
be  certified nor forwarded by registered mail.

                                   Respectfully,

                                   [signature]

                                   Special Attorney for the
HS:nba                             Department of Justice.
```

In December of 1942, Gen. Leslie A. Groves and Col. Frank T. Matthias came to the Columbia Basin, looking for a place to build a secret government plant. The climate, the remoteness, and the Columbia River made the area a perfect location. Unfortunately, the people already living there would be required to leave, and in a hurry. This letter is representative of those sent to families to inform them that they would have to leave their homes in White Bluffs, Hanford, and Richland.

The *Benton County Journal* was an early newspaper distributed in Richland. When the government came and declared that the private property in north Benton County would be seized, the paper reported it in this March 1943 edition. Residents were shocked when they read about it and wondered what the government needed the land for.

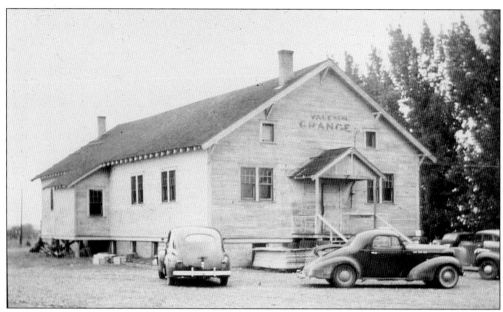

Vale Grange served early Richland residents. The grange was established in 1916 to represent area farmers and orchard growers. This building was used as the headquarters for the Smith, Hoffman & Wright Company, the contractor that would build the homes for the new Richland. The grange hall was torn down, when the Lutheran Church was built on the same site at the southeast corner of the Stevens and Van Giesen intersection.

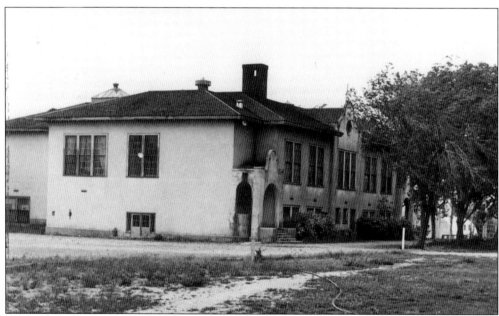

Shortly after the north Benton County property was condemned by the government, Richland School District #6 was disbanded. All Richland schools were closed. There were no graduation exercises that year. The American Legion used the first floor of the old high school after the school closed. The Community Council also used the building. The school stood empty for some time. The present-day Lewis and Clark Elementary School stands on the same spot.

Two
THE WAR YEARS

Dupus Boomer is a familiar character to Richland residents. Dick Donnell, an early Hanford worker, drew the cartoon to poke fun at life in Richland, lampooning its weather, houses, traffic, and many other subjects. This particular picture makes fun of the frequent dust storms in the area, which caused some workers to pack up and leave. Dust storms are still a frequent phenomenon in the area.

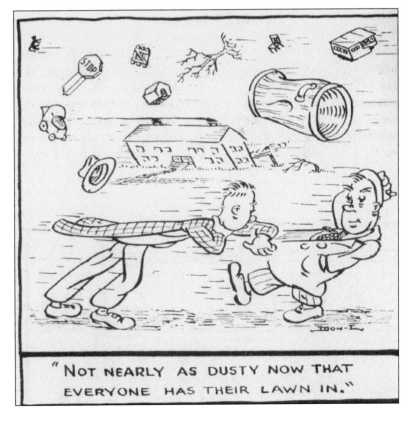

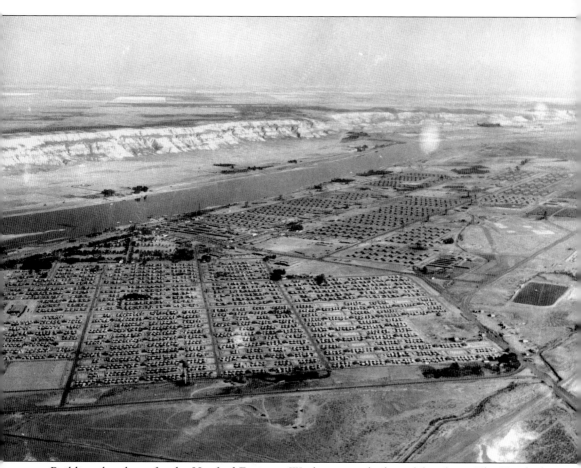

Building the plants for the Hanford Engineer Works required a huge labor force. The Hanford Construction Camp was built to house the workers. As many as 51,000 people worked here during peak times. The camp resembled a military camp with barracks for single men and women. Workers with families lived in privately owned trailers. At one time, the trailer camp was the largest of its kind in the world with over 3,000 trailer homes. The camp had its own hospital, churches, and recreation hall. There was very little in the way of decorative vegetation, except that left behind by the evacuation of the old town sites.

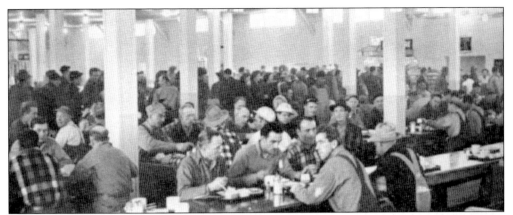

The Hanford Construction Camp fed its workers, too. But it was nothing fancy. Eight mess halls were built throughout the camp. At one time, 2,700 workers could be served. Combined, the mess halls served 8,000 pounds of coffee and 120 tons of potatoes per day and 7,200 pies and 40,000 heads of lettuce per meal. On hand were 250 milk cows to provide milk for breakfast.

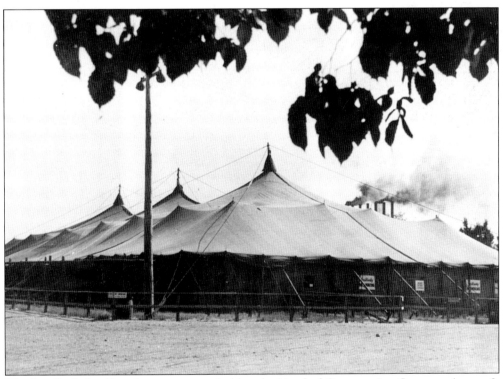

The first Catholic Church services were held at the Hanford Construction Camp on August 8, 1943, in a huge canvas tent. But the congregation quickly outgrew the original white tent and its seating capacity of 150 people. This large circus tent, covering about half an acre of dirt floor, took its place. Father William J. Sweeney held services in the new tent, which seated about 1,500 people. Wooden benches were used for pews and kneelers.

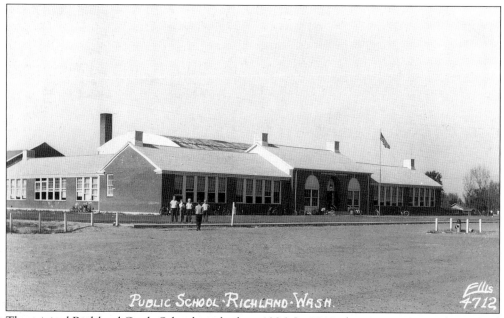

The original Richland Grade School was built in 1936. In 1943, the government took over and renamed it Lewis and Clark Elementary School. The school re-opened on January 16, 1944, after additions had been made to the original building. Lee Clarkson was the principal and stayed until 1966, when he retired. Another wing was added in 1948 to ease overcrowding while further modifications were made in 1970.

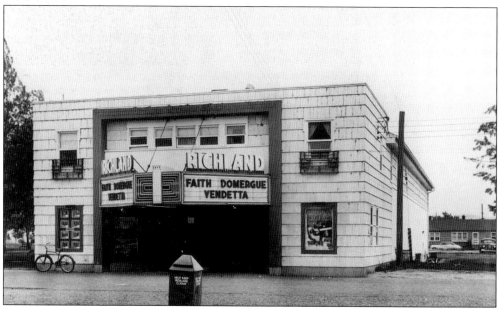

Government occupation of Richland led to a huge building boom in the area. The Richland Theater opened on February 17, 1944, one of the earliest new businesses. It was located on the south end of the Parkway and was operated by the Midstate Amusement Company. The first show was *The Gang's All Here* with Benny Goodman and Alice Faye. The theater is one of the few World War II-era public buildings that still stands in Richland.

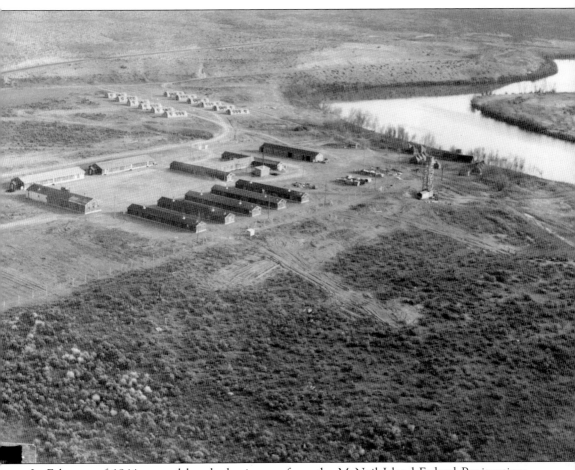

In February of 1944, several hundred prisoners from the McNeil Island Federal Penitentiary were housed in this camp near the modern Horn Rapids Dam, about 15 miles north of town. Many of them were conscientious objectors. They were brought here to harvest the orchards left behind by the former residents. The fruit was sold to the military and other government agencies. In 1947, the camp was taken over by Morrison-Knudsen employees who worked on the railroad. The camp was used until the spring of 1950. The buildings were then moved into town and used by the school district and other locations on the Hanford Site.

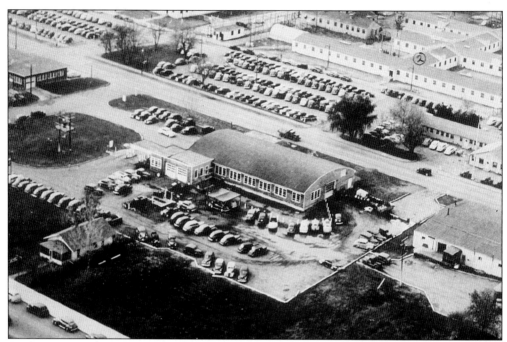

Motor vehicles were bought and serviced at Walt Symon's Ford Agency and Johnny Gerdes Union 76 Station. The structure was built in 1944. The "Little White House" on the George Washington Way side (left) of the building was an insurance agency owned by Max Walton and Jack Hill. In 1951, the public library moved to this building from its tiny quarters on Lee Boulevard.

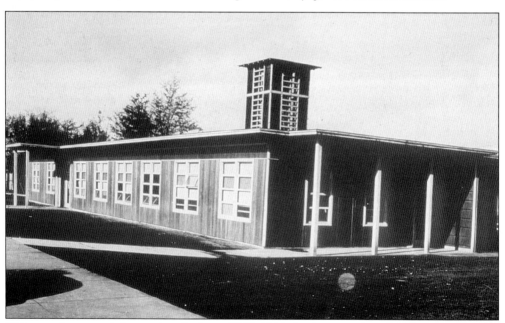

This was the central fire station, built in 1943–1944. It also served as the housing office for newcomers. The fire station later moved one block east to George Washington Way. The Benton-Franklin County Health Department used the building for a time. That organization moved to new quarters in 2000, when the building was torn down to make way for a new police station.

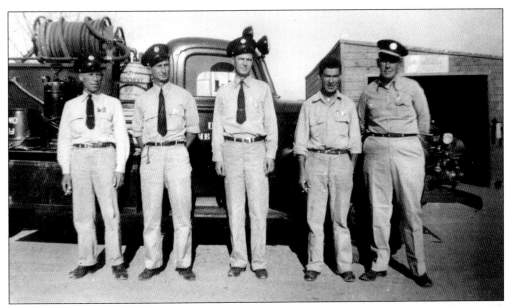

This group of early firefighters stand near their firefighting truck and equipment. Their truck wasn't much bigger than a modern pick-up truck. Like many, Harold Young, second from right, brought his family to Richland in the early days of the Hanford Site. When he arrived housing was not available. He rented a house in Walla Walla, 60 miles away, until he was able to purchase a house in Richland.

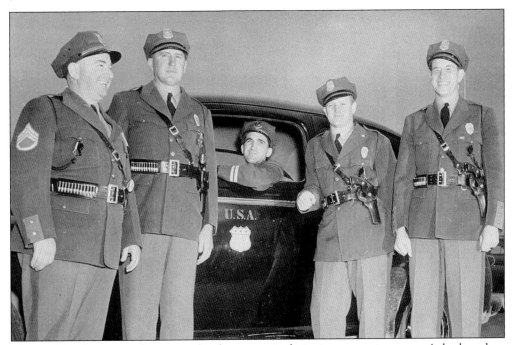

The Richland Singing Cops was the first organized singing group in town. A barber shop quartet, the group entertained residents starting in March of 1944. From left to right are Sergeant Charlie Sergeant, K.C. Jones, Harold Hofsted, and Paul Beardsley. Sitting in the car is Captain Otis Cochran. The men were all members of Hanford Patrol, employed by DuPont.

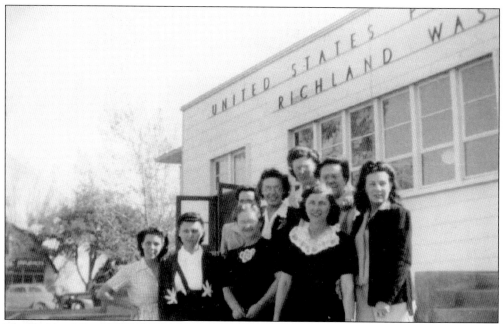

The Richland Post Office finished its new building on April 24, 1944. It was located on Knight Street between George Washington Way and Jadwin. Mail delivery began on July 10. The postmaster was E.C. Peddicord. A new wing was added in November of 1948. The names of these ladies are lost to history, but they are likely employees. The post office moved across the street to the federal building when it opened in 1965.

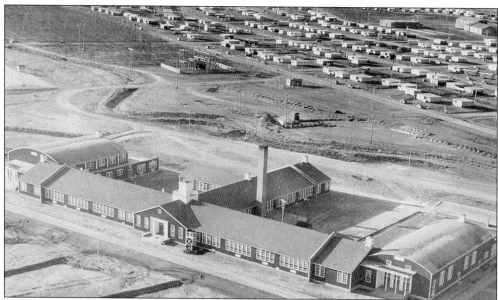

The new high school, called Columbia High, opened in May 1944 with 227 students. Joe Barker was the first principal. The grounds also contained an auditorium, baseball diamond, track, and football field. In 1948, a boy's gymnasium, more classrooms, and auto and woodworking shops were added. In 1955, McIntosh Hall (Mac Hall) was added, named for L.A. McIntosh, a former principal. Another gym was added in February 1964. A new auditorium was added in 1982.

The Richland branch of the Seattle First National Bank opened on May 1, 1944. It was located on the corner of George Washington Way and Knight Street. The front faced north on Knight Street. The TRW building occupies the space today.

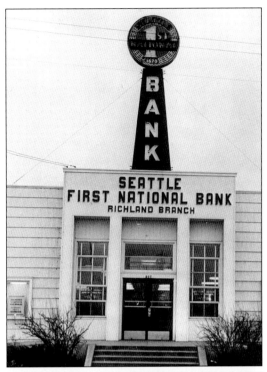

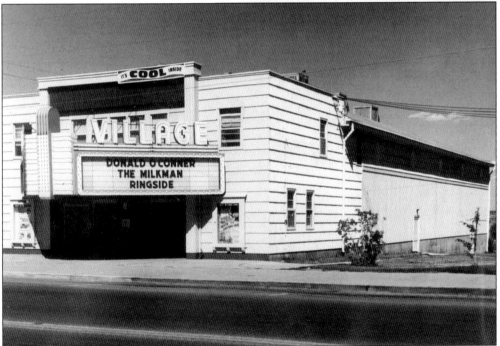

The Village Players held their first show at the high school auditorium, an old-fashioned minstrel show, on May 27, 1944. Ray Ribak directed. The players would later move into this theater, built later that year. The theater was torn down and the lot is now part of the Red Lion Hotel parking lot.

Kadlec Hospital opened in June 1944 on Swift Boulevard between Goethals and Stevens. The building had several one-story connecting wings. Originally called Richland Hospital, it was renamed Kadlec Hospital after Lt. Col. Harry R. Kadlec, an engineer for the Manhattan District. Kadlec was the first man to die there, apparently from over-work. Part of the hospital was torn down to make room for the new four-story structure, which was completed in 1971.

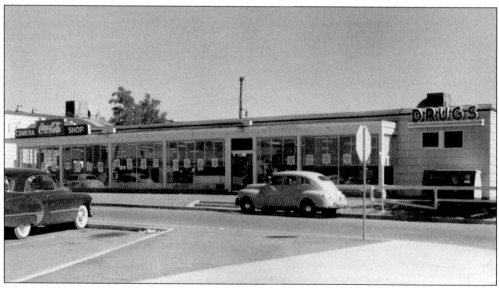

This is the original Thrifty Drug Store, which opened on June 16, 1944, west of the Richland Theater at 602 The Parkway. Marvel Morgan was the manager. It had a full camera shop and toy selection. Several insurance offices occupy this space today.

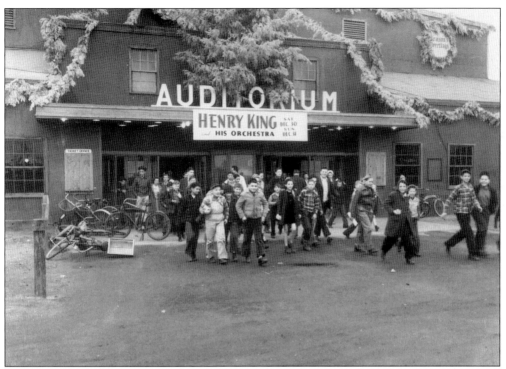

This auditorium at the Hanford Construction Camp opened on June 24, 1944. Incredibly, the auditorium was built in just two weeks in order to accommodate the arrival of some entertainers. The facility was also used for dance bands, shows, and expositions. Big name performers performed at the auditorium, such as Kay Kyser, Jan Garber, and Henry King. The performers were bused out to the auditorium.

This promotional booklet was printed to entice people to work at the Hanford Site. The booklet made it clear that they would be working on an industrial war project, but it did not tell what the project was. The climate of the area, recreational opportunities, and accommodations were highlighted in the booklet. Appealing to a man's appetite, the full mess hall menu was included. The writer estimated costs one could expect to incur while living at the Hanford camp.

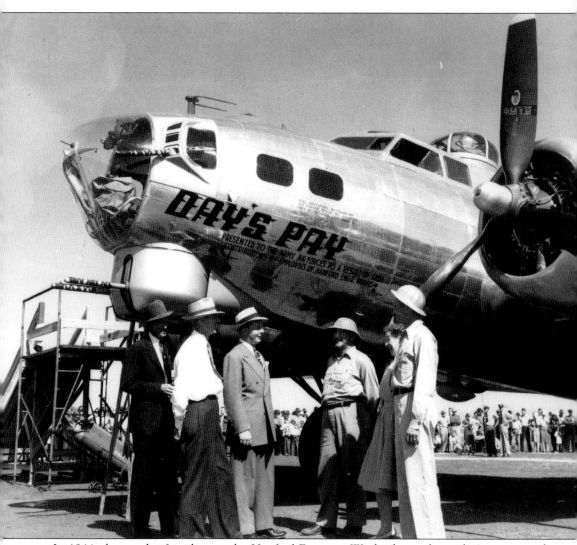

In 1944, thousands of workers at the Hanford Engineer Works donated one day's pay toward the purchase of a B-17 Flying Fortress. At this point, the workers did not yet know about the atomic bomb. Contributing a day's pay was a tangible way that workers could show their support of the war effort. The bomber was christened *Day's Pay* on July 23, 1944. The bomber would be flown over 60 missions in Europe. Purchase of the bomber was a unique gesture of camaraderie and patriotism that would be difficult to duplicate in modern times.

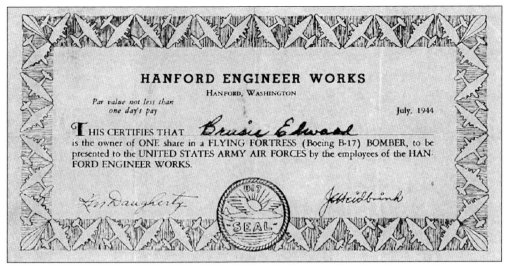

Day's Pay certificates were awarded to each person who contributed a day's wages to purchase the B-17 bomber. Thousands of such certificates were awarded. In December of 1945, residents began an effort to try to purchase the bomber back. On December 4, 1947, these workers learned that the B-17 had been scrapped along with many others at an airfield in Kingman, Arizona.

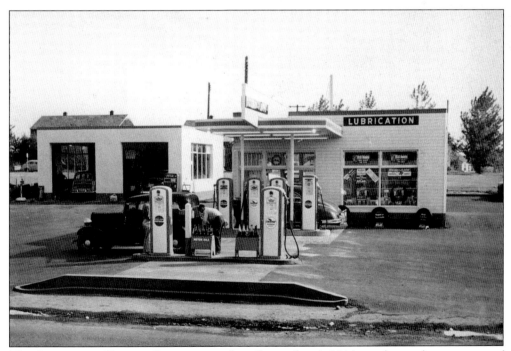

The Community Chevron Station opened on September 4, 1944, on the southwest corner of Goethals and Symons. The station was owned and operated by Jerry Pleiss. At the time of this picture, the station was celebrating five years in the community. Recent remodeling added a lube station and washroom and three more gas pumps. The station employed six employees and provided lubrication, tire, and battery service.

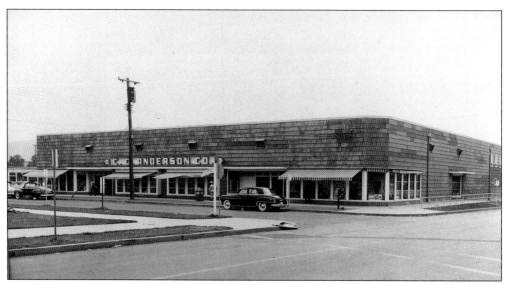

C.C. Anderson Co. opened on September 5, 1944, at the southeast corner of Lee and Jadwin. The building was bought by the Bon Marche in 1962. The Bon Marche occupied the building until it moved to the Columbia Center Mall in Kennewick in 1969. Today the building hosts Ariel Gourmet and Gifts, Abadan, Perk's Sewing Yarn and Quilting, and the Richland Accounting & Tax Service.

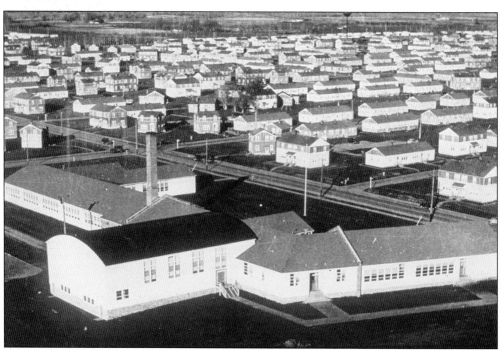

Sacajawea Elementary School opened on the southeast corner of Williams Boulevard and Stevens Drive in September 1944. The first principal was Lillie Peterson. The enrollment outgrew its capacity and a new Sacajawea School was built on Catskill and opened in 1972. The old school was closed in 1973 but was used for several more years by a variety of organizations, such as the Washington Association of Retarded Citizens. It was finally condemned and torn down.

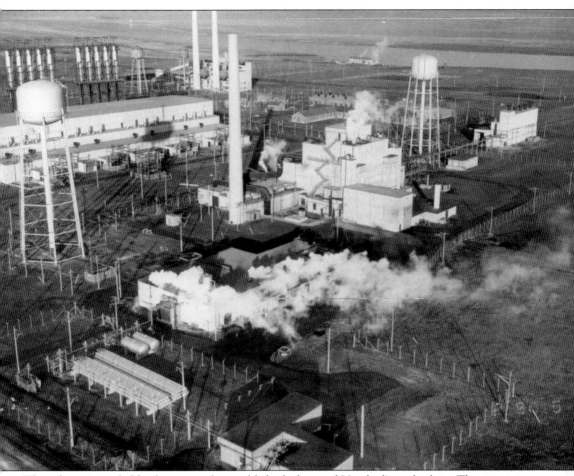

This photo is probably the most often published photo of Hanford's early days. The picture depicts the B Reactor, the first nuclear reactor to go "on line" on September 26, 1944. The reactor is the wedding-cake shaped building at center-right. Crews worked six eight-hour days, then nine-hour days, to finish the reactor in record time. Floodlights enabled the men to work 24 hours a day. The smaller building to the right was the 108-B Building, where the first tritium separation was conducted. Tritium was used in the first hydrogen bomb tests. B Reactor was shut down on February 15, 1968, and placed on standby.

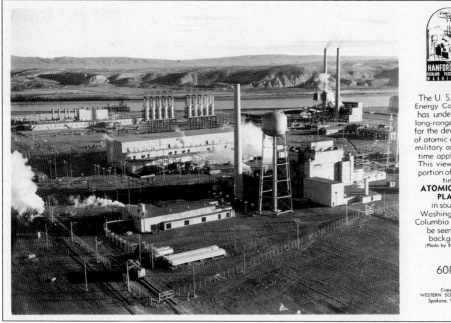

B Reactor was important in producing plutonium, but it also demonstrated the possibility of using nuclear power for generating electricity. In 1976, B Reactor was named a National Mechanical Engineering Landmark by the American Society of Mechanical Engineers. In 1989, it was nominated to the National Register of Historic Places. In 1990, the B-Reactor Museum Association was formed to preserve the reactor as a museum.

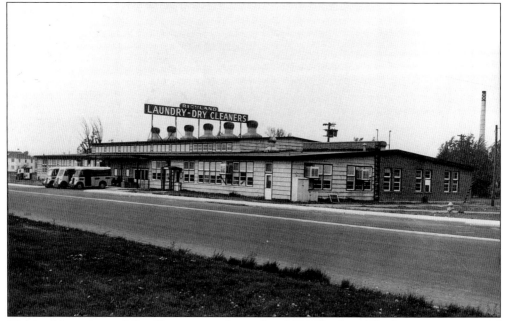

Richland Laundry and Dry Cleaners was located at 1106 Harding. The business was opened in 1944. It is one of the few businesses from that era still operating today. It is also in the same location.

The Recreation Hall opened on December 23, 1944. It was operated by L.C. Foisy of Prosser. When opened, the hall contained a bowling alley, billiard room, and canteen. A tavern and dining hall opened later. It also contained a large lounge and two smaller rooms that could be rented for weddings and meetings. This building is used today by the Children's Museum, though it is quite dilapidated. Sadly, this vintage building may be slated for demolition and replaced with a parking lot.

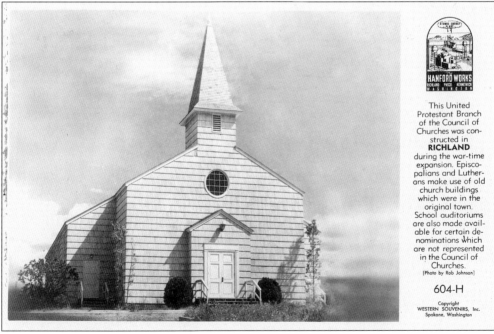

The Central United Protestant Church held its first services on December 24, 1944, at which the congregation heard its new Hammond organ for the first time. The church was formally dedicated on January 9 and 14, 1945. Reverends Kenneth Bell and Thomas Acheson were there to tend their flocks.

33

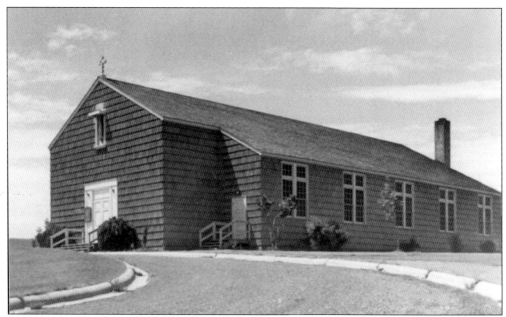

Father Sweeney served the first mass in the new Catholic Church on Christmas Eve, 1944. Before erection of the building, services for Richland had been held at the old high school auditorium and the grange hall. The new church, on Stevens and Long, held 700 people. On June 7, 1954, the church was sold to the congregation. This church was replaced with a larger building in 1982. Services were held in the adjoining Christ the King School while the new church was under construction.

At the same time the Hanford Construction Camp was being built, the government was frantically building houses in town. These homes became known as the "alphabet houses" because the models were designated with letters. Each house had a fixed layout for its design. This house is a typical "H" house, which had three bedrooms. Half of them also had a finished basement. Approximately 250 of them were built between 1943 and 1945.

This house was one of just 44 homes built between 1943 and 1945. The "L" house was the only model that had four bedrooms. About half of these homes had a basement. They all had coal heating. The exterior dimensions were 24 feet by 32 feet. At the time the alphabet homes were built and for many years afterward, the government supplied all repair services, including appliance repair.

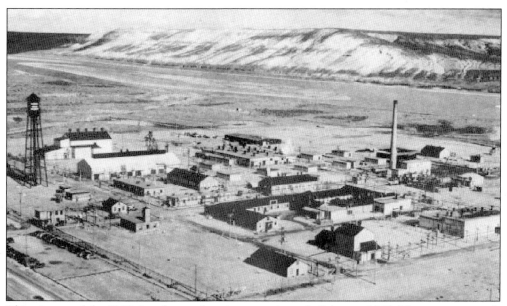

This picture of the "300 Area" was taken in approximately February 1945. The area was much smaller than it is today. The large dark building at center was known as the 3706 Building, where laboratories and radioactive "hot cells" were located. The multi-story building to the left of center contained a test reactor.

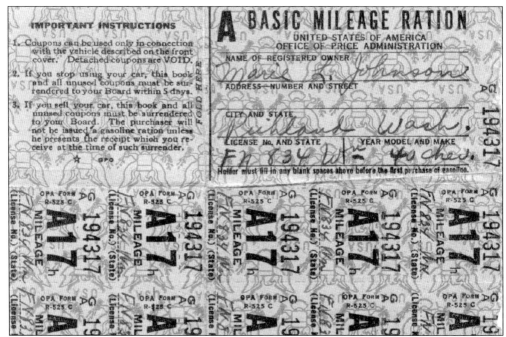

In some ways, Richland was just like other cities and towns in America during World War II. The town experienced shortages and rationing. These gas coupons were issued to families for their monthly gas allotments. "A" stickers allowed a 16-gallon per month allotment. "B" stickers allowed 37 gallons per month. Doctors, nurses, defense workers, and civilians employed by the military were not subject to rationing of gas.

This cafeteria was located at the southwest corner of Jadwin and Knight Street. The building served the residents of the nearby dormitories as well as the government employees in the "700 Area." After the war, Roy Davis Furniture occupied the building until it moved to the Uptown Shopping Center. Today Sirs & Hers Hair Salon, Spink Engineering, and several other small businesses occupy the old building.

THE SANDSTORM

Published by the Journalism Class, Columbia High School, Richland, Washington, Friday, January 12, 1945 Volume 1, Number 5

F. Maroney Takes Over Recreation

"My idea of a good recreational program is to add any activities to it that are wanted by the students," stated Mr. Frank Maroney, new recreation and physical instructor at Richland High school. He hails from the state of Minnesota, his home being at Marshall.

Mr. Maroney participated in high school and college sports, and for fourteen years was coach of athletics in various high schools and at Mankato State Teachers College. He was director of athletics at the Le Sueur, Minnesota, High school before he came here. The main reason for Mr. Maroney's coming to Washington was that he was employed by the Blue Mountain Cannery Company in Pomeroy and Dayton, and the country proved to be to his liking, especially the climate, since Minnesota is pretty cold.

The new recreation program provides that each Thursday night be set aside for all boys not participating now in the regular intra-mural basketball leagues or that play on the varsity and junior varsity. A separate league will be formed for these boys, and teams will be chosen to play regular games. These teams will probably not be chosen according to Physical Education classes, as there will not be enough boys from each class. Also, Monday nights are being set aside for general recreation. This program includes ping-pong, volley-ball, badminton, tumbling, wrestling, and boxing.

(Continued on Page 3)

P.-T. A. Discusses Teen-Age Recreation

At the third regular meeting of the Columbia High P.-T. A. held in the Auditorium Tuesday evening, January 9, interest centered around the need for constructive guidance for high school age students. Mrs. Myers, counsellor for the girls led the discussion and expressed the views of the student body.

Acting upon a motion presented by Mrs. Fred Otto and discussed by Mrs. Zeller the organization voted to offer its support to the "Teen Age Club" for whatever aid and assistance that club may deem necessary in promoting its activities. A group consisting of Mrs. Zeller, Mrs. Meyers, Mrs. Otto, Mrs. Ruffing and Mr. Maroney was appointed by the president to offer the assistance of the P.-T. A. to the "teen-age" organization.

Following a musical number from Sacajawea School under the direction of Mr. McDonald, Senior high school girls guided parents

G. A. A. Formulates Conduct Rules

Punishment for the misconduct of the girls of Columbia High School is no longer a problem, since a committee of twelve members of the G. A. A. decided on suitable penalties for the girls' offenses. The most popular penalty will be the wearing of a sign stating the crime committed. The signs have been made by members of the Girls' League and of the G.A.A., who will also enforce the rules. Any girl refusing to wear a sign will appear before a court of the Girls' League if proven guilty, her punishment will be much more severe.

The offenses calling for the wearing of a sign for one week are smoking in the building and on the school grounds, defacing the walls anywhere in the building (also clean the wall and lavatory for one week, destroying school or any person's property (replace property), tampering with any lock or locker other than her own, stealing the school's or any individual's property (also turned over to the patrol).

For gambling in the building or on the school grounds and throwing paper, parts of lunches, or other debris in the halls or on the school ground, the punishment will be the wearing of suitable signs for two days.

Signs will be worn for one day for the following offenses: running and pushing in the halls, the use of profane or obscene language in the building or on the school grounds or wearing of slacks to school.

Whistling or booing in assembly will be punishable by wearing a sign and sitting on the back row for the next two assemblies. This is also true for sitting in the wrong section.

G. A. A. members late to meetings will have to go through a swat line. G. A. A. members violating the rules will also have to go through the swat line and into the showers.

It is hoped that this will stop the growing abuse of school rules and that student co-operation will stop this "crime wave."

Coaches Start Sports Program

Beginning soon a program of intramural sports for the students of Columbia High will be put into effect by Miss Stephenson and Coach Hoff. Besides the regular Tuesday and Thursday nights in the gym, the boys will also be given every other Monday night. Every second Monday night there will be a co-recreational program. On Wednesday night the girls will take 'over. The sports will include basketball, volley-ball, ping-pong, badminton, tumbling,

Mumm And Erickson Win Leads In "Miss Jimmy"

L. E. Mahon Gives Voice Lessons Here

It looks as if voice lessons are on the way at Columbia High with a lovely new teacher, Miss Laura Edna Mahon in charge. This grand lady hailed from Northfield, Minnesota. She attended Carlton College there and received her Masters of Music degree. In her travels she has visited Salzburg, Austria, where she attended the Mozarteum founded in honor of the great composer Mozart.

Here she took opera coaching and orchestra directing. She has also taught at the University of Washington. Since this is the first time she has ever taught in high school, she said that she was literally swept off her feet by a group of hungry girls on the way to the lunchroom, thus she feels one of us.

Incidentally she has known a number of famous opera stars and orchestra directors. Among them are Fredrick Martin and Andre Kostalentez.

Kennewick Next Foe

The rampaging Kennewick Lions star quintet in the lower Yakima Valley League, play Richland tomorrow night, Saturday, January 13, in the Columbia High School gymnasium. The Lions have been undefeated in this league, but were nipped by Yakima 35-29. Perkins, center and pivotman, is their outstanding player, and it is the Beavers' job to stop him. Richland has won one game and lost three during the season. This comparatively poor record is due partly to the loss of several first-string players.

Next week the Beavers tackle Riverview in another home game Friday, January 19. Nothing is known of the quality of this team but in past years it has been good, and a strong aggregation is expected.

Confusion Explained

There has been quite a bit of confusion concerning the identity of the Girls' League and the Girls' Athletic Association. Some of this bewilderment might be due to the "G" in each title. The Girls' League has been organized under the direction of Mrs. Josephine Myers for the girls enrolled in the Columbia High School. The other sponsors of the Girls' League are Miss Ruby Stephenson, Girls' Athletic Association; Mrs. Olive Anderle, entertain-

Dramatics Produce College Farce

Allen Mumm and Elaine Erickson won the leads in "Miss Jimmy," a farce in three acts by Jean Provence, to be produced by Miss Simpson's Dramatics class in February.

Allen interprets the part of Jimmy, who is about twenty-one, very goodlooking and enthusiastic about life and college. Elaine portrays the part of Louise (Leu), a girl of nineteen, who is pleasant, sensitive and sincere although she is not quite through reading Grimm's Fairy tales and is still looking for Prince Charming.

Betty Yaggi plays the part of Florence (Flo), who has finished with fairy tales and is now reading blood and thunder mysteries. She is also a bit pert and awkward. Betty Zellers has the part of Catherine (Kitty), who is the type men prefer and she also prefers men. She is bright, forceful and rather selfish.

Marlyse McGauvron takes the part of Doris (Dot), who is the youngest and is still impressed by her upperclassmen and can be depended on to deliver something when there is an order. June Garrison, who is acting as Harriet, is slightly sluggish and a rank snob, has been spoiled at home and still expects her school mates to cater to her. Clifford Nall, who plays the part of Droopy, is just exactly that. He is a Southern Negro and is "about as fast under his hat as he is on the ground, but is willing and that is something."

Lois Stordahl, who is acting as Miss Watkins, on the surface is very hard and cold, but down deep a human being can be found. She is still waiting for her boy friend who went to Cuba with Teddy Roosevelt to fight the Spaniards. Jack Turner is Professor Frazier, who was the pride of the English department when he was in college. The English culture didn't stick with him, but the accent did which you will be able to see.

Look for future details in THE SANDSTORM.

Shop Boys Are Handimen

Shop has turned out some excellent music stands. Owen Roberts has made a cart and Kenny Grubb has made a medicine cart for the basketball boys who get a scrape here and there.

Anybody who can do any entertaining see Miss Simpson or Miss L. Brown before Friday, January

The high school journalism class produced a school newspaper, named for Richland's famous sandstorms. These early papers had just four pages and were printed on cheap newsprint. The paper was printed in Pasco and distributed on Fridays. Each edition cost 5¢. In this edition, dated January 12, 1945, the high school mascot is the Beaver. That fall, Columbia High School students' new nickname would be the Bombers.

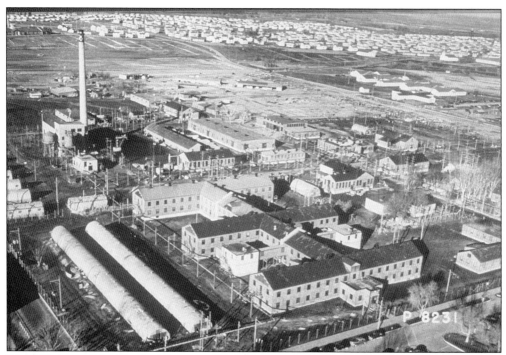

The 700 Area of the Hanford Engineer Works was located in downtown Richland. These were mainly office workers. Surrounding the government buildings, such as the prominent "H"-shaped 703 building in the foreground, were the men's and women's barracks for unmarried workers. A coal plant supplied electrical power for downtown Richland.

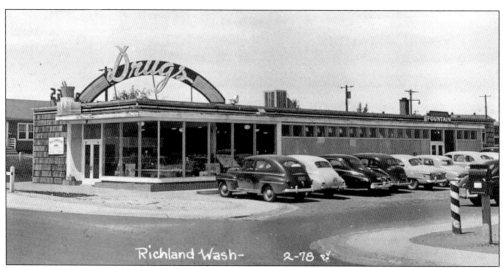

Simply called The Drug Store, this business opened in 1945 at the northwest corner of Goethals and Symons. Later the store was known as Castleberry's, then Village Pharmacy, then Ray's Village Pharmacy, and finally Malley's Pharmacy. Today Delmax Furniture Repair & Custom Upholstery occupies the same space.

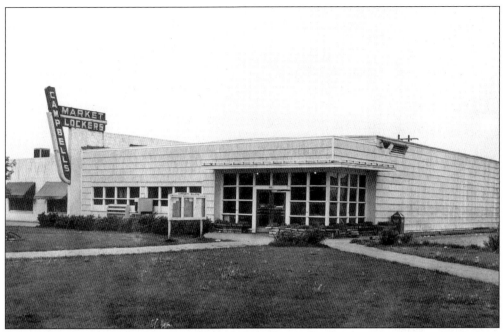

Campbell's Meat Market opened in 1944 at 704 Comstock, near its intersection with Jadwin. Richland Floral shared the space with Campbell's. The owner, K.I. Campbell, was elected president of the Chamber of Commerce. The site is now occupied by Columbia Foursquare Church.

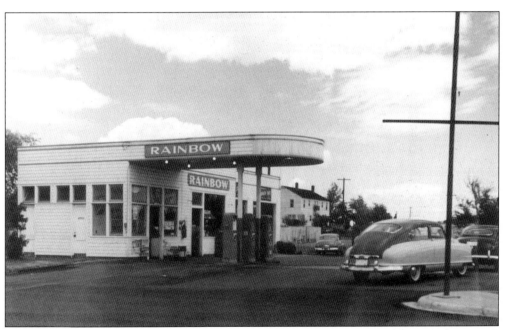

The Rainbow Gas Station was built at the northwest corner of Casey and Comstock in 1945. The manager was W.K. Woods. The building is still standing, but has been partitioned into four small businesses: Tri-Cities Maintenance & Janitorial, United Food & Commercial Workers Union, AccuWall Drywall, and Western Reflections, an art gallery.

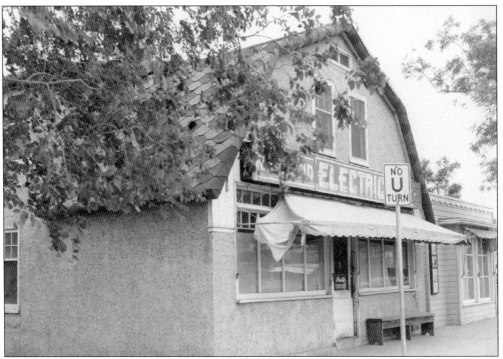

Richland Electric & Appliance occupied the building once used as Hanford Patrol Headquarters and opened for business in 1945. Johnson & Reutlinger also did business there, as well as Pauls Inc. and Ernie's Printing. Eventually the building was torn down and became part of a parking lot that serves the Red Lion Motor Inn (old Hanford House).

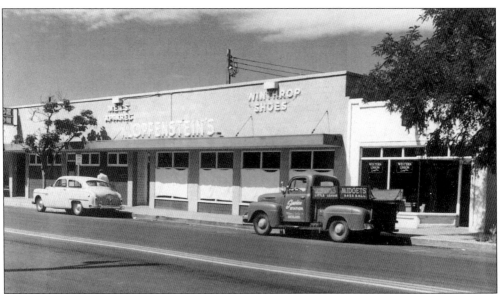

Klopfenstein's clothing store was located in downtown Richland on George Washington Way. It opened in 1945. In November of 1949, McCann's Boy's Shop opened in the Klopfenstein building, joining the Les Critzer Shoe Department that was already there. Today the building is occupied by the Frontier Tavern and the Gladstone & Swisher Law Firm.

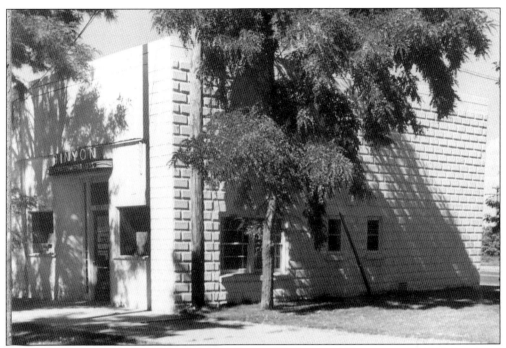

Binyon Optometrist had been located at 711 George Washington Way since early 1945. Doctor of optometry, Dr. Leander Butt, was on duty. Binyon was part of a northwest chain located in other cities such as Yakima, Seattle, and Bellingham. Today the trees are gone and the lot is vacant.

Another early business was the Richland Shoe Salon, located at 624 Biddle in downtown Richland. The business boasted using a state-of-the-art x-ray machine for perfect shoe fitting. Later, after radiation effects were better known, both customers and employees did not like using the machines. They disappeared from the scene.

Morning Milk, a Carnation Delivery Service, was located on 704 Harding, near the Richland Laundry. For years, milk was delivered by truck to Richland residents. Alf Rosberg was the manager in the early years. During the war years, the delivery service encouraged customers to return the bottles for reuse.

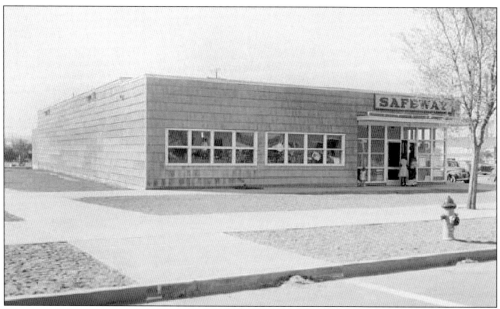

The first Safeway store was located at 605 Goethals, built in about 1945. In 1962, Safeway opened a much bigger building on Lee and Cullum Avenue. The Safeway was abandoned about 1981, when the store moved to the Washington Square Shopping Center on George Washington Way.

The Villager

EXTRA **EXTRA**

VOLUME I Hanford Engineer Works Richland, Washington Tuesday, August 14, 1945 NUMBER 23

PEACE!

OUR BOMB CLINCHED IT

Plant Will Not Close!

The Hanford Engineer Works will not close! It will continue operating indefinitely! Such was the official announcement from the offices of Colonel F. T. Matthias, Area Engineer, and W. O. Simon, duPont Project Manager.

"With the end of the war, project workers are entitled to celebrate and be proud of the big part

Message from W. O. Simon

Text of W. O. Simon's V-J message to all workers.

Japs Surrender

(Special to THE RICHLAND VILLAGER)

WASHINGTON, D. C., Aug.14, (UP)—FLASH President Truman announces Jap surrender terms Japanese Government's message accepting Allied terms says Hirohito is prepared (quote) to authorize and ensure signature (unquote) by Jap Government and Imperial General Headquarters of ne

Before the atomic bomb was dropped on Japan, few workers had any idea what was being built at Hanford. Several days after "Fat Man" was dropped on Nagasaki by the B-17 bomber known as *Bock's Car*, the Richland *Villager* revealed the role that Hanford workers played in ending the war. Though it was regrettable that many people were killed in the atomic explosions, most felt that a quick end to the war saved many more lives than were lost. Hanford workers were proud of their contribution to the war effort.

E. I. DU PONT DE NEMOURS & COMPANY
INCORPORATED
WILMINGTON 98, DELAWARE

EXECUTIVE OFFICES

August 24, 1945

Mr. Harold L. Young
Hanford Engineer Works
Richland, Washington

Dear Mr. Young:

Within the last three weeks we learned of two heretofore unprecedented attacks upon Japan by our gallant armed forces.

A few days ago we learned of an offer of surrender by Japan, its acceptance by the United Nations and the war's end, for which the millions of citizens of this nation have longed for many months.

The world now knows that these great assaults, which may have influenced the Japanese in their surrender, were made with the aid of missiles employing atomic energy. The War Department has disclosed that the du Pont Company played an important part not only in the development program, but also at the Hanford plant where a new chemical element to make possible the release of such energy has been produced.

I, and my associates here in Wilmington, have a feeling of great pride in the contribution which you and your fellow workers have made in this great cause. I wish to express to you my sincere gratitude for your help.

I have written a letter which tells something of the background of du Pont's connection with this project and some data of a non-technical nature showing what was done. This letter will be sent to all of the other employees of the du Pont Company. Though you are better acquainted with this program due to your participation in it, I am enclosing a copy of this letter believing it will be of interest to you also.

With hearty appreciation for all which you have done in furthering this program of such national interest, I am,

Yours sincerely,

W. S. Carpenter, Jr.
President

WSC:JVT
Enclosure

A few days after the Japanese surrender, DuPont sent personalized letters to each Hanford employee. The letters thanked the workers for their contribution not only to ending the war, but also to new scientific discoveries.

THE Significance

OF THE ARMY-NAVY "E"

The Army-Navy Production Award is a salute from our fighting forces to the soldiers of industry. The flag which symbolizes this award has a rich tradition in the history of our armed forces. In 1906 the Navy instituted in the Fleet an award for excellence which has been known ever since as the Navy "E". First awarded for excellence in gunnery, this was later extended to include outstanding performance in engineering and communications. An honor not easily won nor lightly bestowed, it became and has remained a matter of deep pride to the men of the Service who receive it.

When the rising tide of war in Europe placed a premium on the production of war equipment, the Navy "E" award was extended to embrace those plants and organizations which showed excellence in producing ships, weapons, and equipment for the Navy.

Then came Pearl Harbor — and with it a demand for war production such as the world has never known an awareness that our fighting forces and the men and women of American industry are partners in the great struggle for human freedom and on the part of all Americans a grim and enduring resolve to work and fight together.

From that high resolve was born the Army-Navy Production Award — which stands today, as our fighting forces' joint recognition of exceptional performance on the production front of the determined, persevering, unbeatable American spirit which can be satisfied only by achieving today what yesterday seemed impossible.

The Army-Navy Production Award is not lightly given nor should it be lightly received. It carries a great patriotic challenge and entails a pledge of service from us all. The standards which earned this award must be continued and even bettered. We can do no less — and fly this award pennant with honor.

Presentation

of the

ARMY-NAVY PRODUCTION AWARD

to the

MEN AND WOMEN

of the

TNX DIVISION, EXPLOSIVES DEPARTMENT
E. I. DU PONT DE NEMOURS & CO., INC.

at

HANFORD ENGINEER WORKS

OCTOBER 20, 1945

RICHLAND, WASHINGTON

The military also remembered the workers of Hanford in a special awards ceremony, held on October 20, 1945. This special award is called the Army-Navy Production Award and is given to recognize excellence in performance. The contribution of the Hanford workers was honored in a special ceremony in which the award was presented by Major General Leslie R. Groves, Officer in Charge of the Manhattan Engineer District.

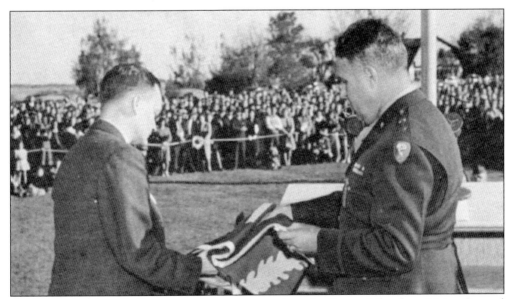

Dr. Bill H. Mackey, DuPont general manager, receives the E award flag from Major General Leslie R. Groves. Also on hand was DuPont president Walter S. Carpenter.

This aerial view of Richland looks northwest. George Washington Way curves north to meet Lee Boulevard in the middle of the picture. The Community Center stands in the right foreground. The large square building near the center of the picture is the C.C. Anderson department store. Barracks buildings are visible in the background. A large part of town remains undeveloped. The picture was taken about 1945.

This aerial view looks southwest. The Transient Quarters and parking lot stand in the foreground. The grassy area to the right-center would later become the John Dam Plaza. To the south of the plaza is the post office and Seattle First National Bank. Other new homes in south Richland are clearly visible.

Three
THE POST-WAR YEARS

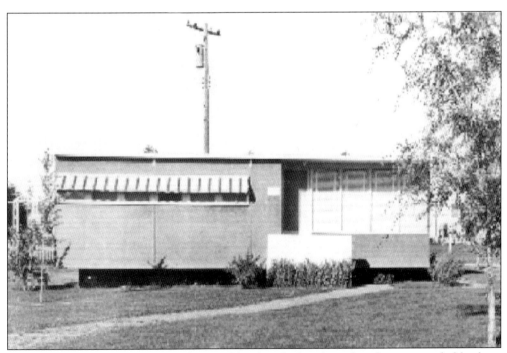

Prefabricated homes were shipped to Richland and placed on foundations, much like later mobile homes. From 1944 to 1946, approximately 1,200 "prefabs" were installed. Prefabs had either one, two, or three bedrooms. This picture is a typical three-bedroom prefab. Even so, it was still small with overall dimensions of just 27 feet by 32 feet, 3 inches.

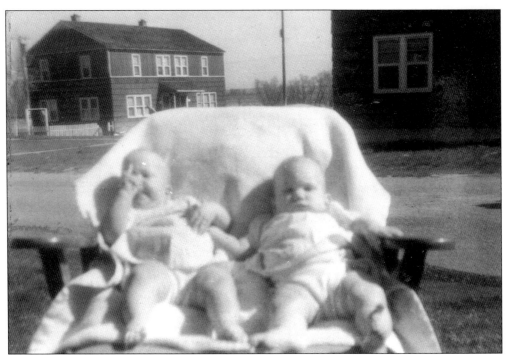

The birth-rate at Richland was nearly twice the state average. At one time, Richland had the highest birth-rate in the country. Between June of 1944 and October of 1958, 11,106 babies were delivered at Richland Hospital. Pictured are twins Carol and Helen Evans, born in September of 1946, 2 of 451 births that year.

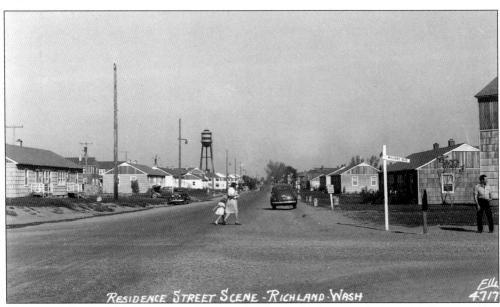

This view of a residential street is taken from Williams, looking north down McPherson. This typical block of government houses contains mostly "A" and "B" houses. Both are two-family homes, with the "A" house consisting of two stories and the "B" house having just one story. Some of these homes were later converted to single-family homes.

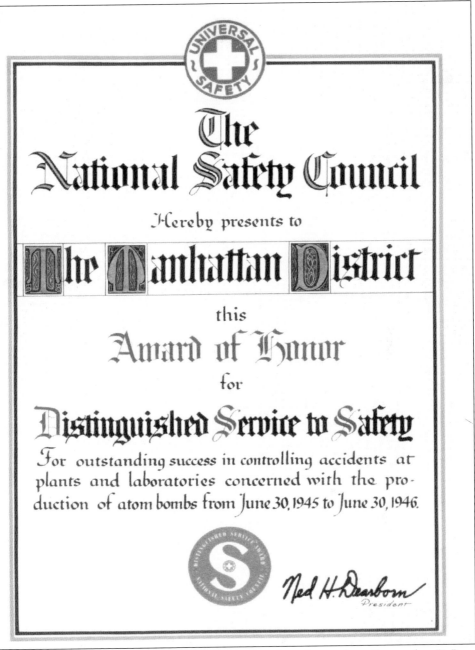

From the early days, DuPont was concerned about the safety of its workers. Even today, DuPont has a reputation for its safety record and even teaches its practices to other companies. This award was given by the National Safety Council to the Manhattan District of the Army Corps of Engineers for its commitment to safety from the period of June 30, 1945, to June 30, 1946. This is especially significant as the extraction of plutonium was going on during this time.

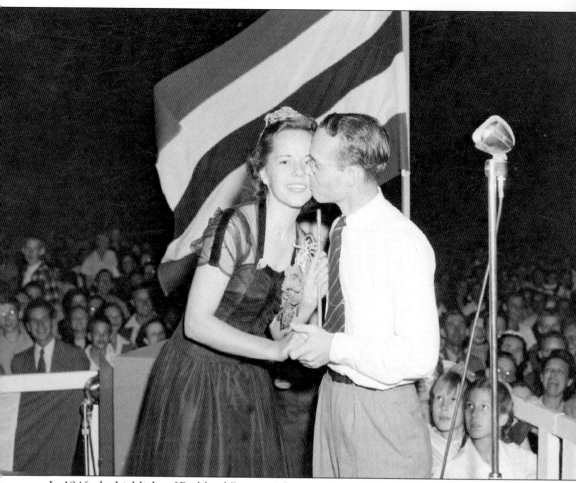

In 1946, the highlight of Richland Days was the crowning of Miss Richland. This year's winner was Sally Byers. Here she receives a congratulatory kiss. Master of Ceremonies Paul Beardsley announced the winner and her court. Other events at the celebration included a street dance, fireworks display, parade, and sports contests. There were also numerous exhibits, everything from handicrafts to model railroads to photography. One of the main events of the celebration was the official hand-off of the Hanford Works contract from DuPont to General Electric. Spectators also waited with bated breath to see who would win the brand new 1946 Ford sedan. Dale Morris was the lucky winner.

After the war ended, the city produced a number of promotional gimmicks such as this decal. Richland considered itself the "atom bustin'" city and printed the slogan on everything, including the Richland *Villager* newspaper masthead. It was also printed on programs and pennants.

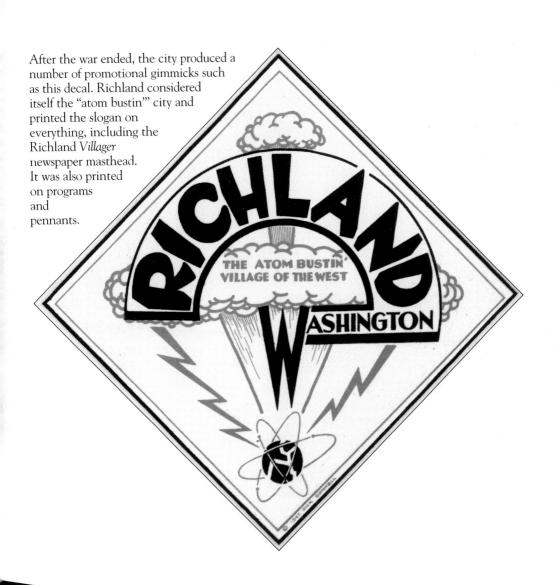

About the same time, this pennant advertised Richland's role as the "atomic city." Though Arco, Idaho, would later declare itself the atomic city because it was the first to receive electrical power generated by atomic energy (1952), Richland owed its very existence to nuclear research and development.

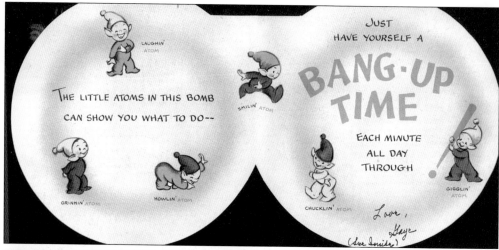

It seems as if fascination with the atomic bomb wasn't confined to the locals. A National greeting card company printed this atomic bomb birthday card in 1946. Inside, cartoon characters represent an "atom" character, who is laughing, grinning, howling, smiling, chuckling, and giggling.

In 1947, the Richland Bombers girls' basketball team had a winning record. From left to right, the girls are Nancy Howard, Maxine Belson, Mary Musser, Barbara Gammon (captain), Shirley Wood, and Helen Baudendistel.

The Boys Federation was organized to promote citizenship and school spirit. In 1947, the boys joined with the Girls' League to organize the Thanksgiving formal and a Christmas assembly. The boys also created a boxing team. Pictured, left to right, are: (front row) Rembert Ryals, Earl Skow, David McElroy, Jack Davis, and Allen Neidhold; (second row) Bob Larson, Kay Connolly, Kenneth Jones, Pat Sheeran, and Wimp Stocker; (back row) advisor Mr. Loos, Gene Conley, and Vernon Larson.

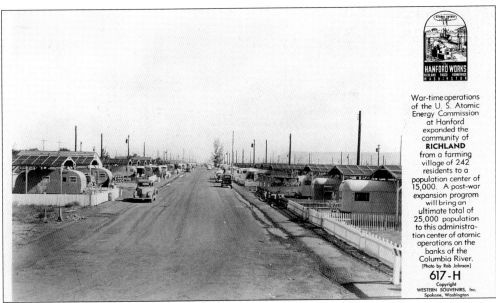

In 1947, when it became known that operations at Hanford would continue, it was obvious that housing availability would fall far short. The government quickly erected this trailer park in North Richland. It was predicted that when fully occupied, 16,000 people would live here. Two barracks buildings were barged across the river from the Pasco Naval Air Station to be placed near the trailer park to house military personnel.

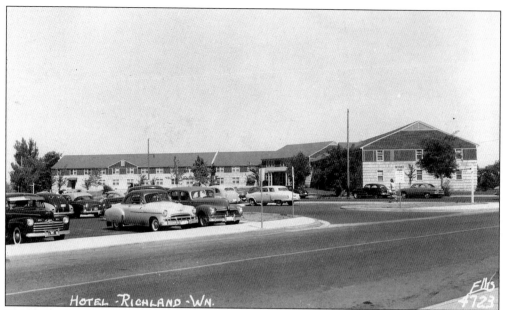

The Desert Inn Hotel still looks like army barracks in this picture. And it should. It was opened on December 24, 1943, as transient quarters for Hanford workers. The business was operated by Progressive Cafeterias. It was usually filled to capacity. The building was located on George Washington Way, where the Red Lion Inn stands today. Vance Properties bought the building on April 18, 1948, transforming the transient quarters into the Desert Inn.

This view of the Desert Inn looks east to west. Besides the regular hotel accommodations, the Desert Inn had a barber shop, candy store, fur store, and large dining room. In 1969, Atlantic Richfield Company-Hanford Operations (ARCHO) opened a new hotel on this spot known as the Hanford House. The hotel has changed hands several times since then.

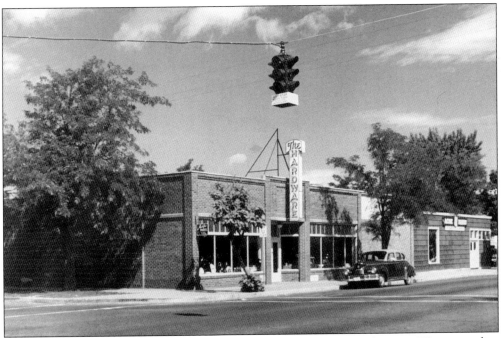

The Hardware Store located on the northwest corner of George Washington Way opened in 1948. It soon outgrew its space and built an addition in late 1948 and again in early 1949. The business was later called Richland Supply Company. Jennifer's Bakery occupied the space in more recent years. Today the Taste Café occupies the former hardware store.

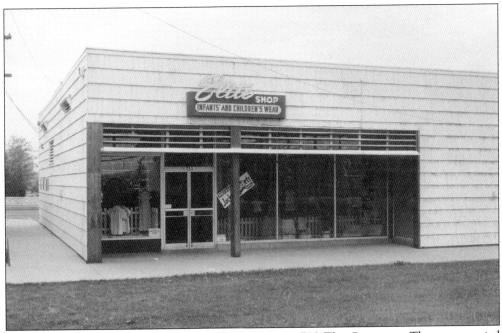

The Elite clothing store opened on April 30, 1948, at 713 The Greenway. The store carried clothes and shoes for boys and girls. Cleda E. Frambach was the manager and Netta C. Saxe was her assistant.

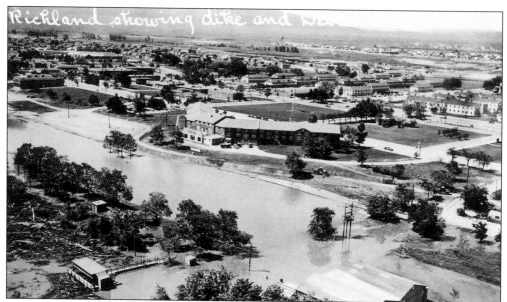

In 1948, record snowfall in the mountains combined with rapid warming in the spring led to flooding all up and down the Columbia River and its tributaries. At the time the Grand Coulee Dam and the Bonneville Dam were the only dams on the Columbia River; flood control wasn't nearly as effective as it is today. Like many other towns, south Richland was severely flooded. This picture shows the water line, right up to the edge of the Desert Inn hotel.

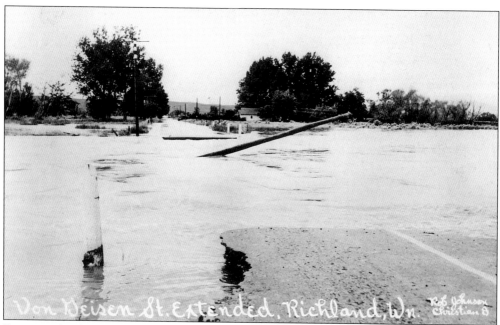

Even two days before the flood waters crested at Richland, officials reported the town would be safe. However, it was soon apparent that it would suffer at least some damage. Luckily, there were no casualties in the disaster, though $50 million in damage was reported. This scene looks west across Van Giesen Street as it heads toward West Richland. The waters of the Yakima were very high too, resulting in much flooding west of the Bypass Highway.

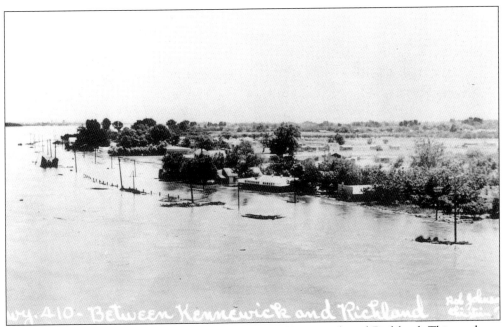

At the time of the flood, Highway 410 ran between Kennewick and Richland. This road was completely inundated by the flood waters. This area was known as the Richland "Wye" area. Many of the businesses relocated after the flood.

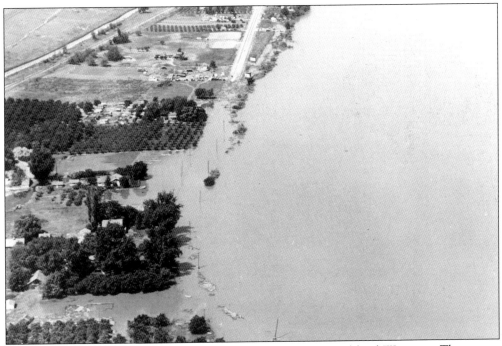

This aerial view shows another view of Highway 410 in the Richland Wye area. There were orchards in the area at that time. Residents were completely cut off from Richland proper. Charles and Wallace Bateman tried to build up the cause-way to their island, just west of the shore line, but it was completely flooded over.

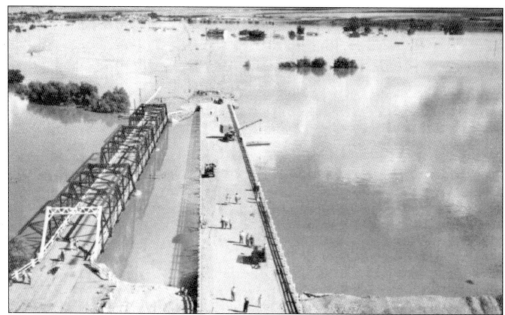

The southern extension of George Washington Way crossed the Yakima River before becoming Highway 410. City officials resigned themselves to the fact that this road would be flooded and it was, in a big way. The road was engulfed and homes and businesses near it were swamped. The large building in the center distance is the old Dutch Mill. After the flood, the road was rebuilt ten feet higher than its original configuration to prevent future flooding.

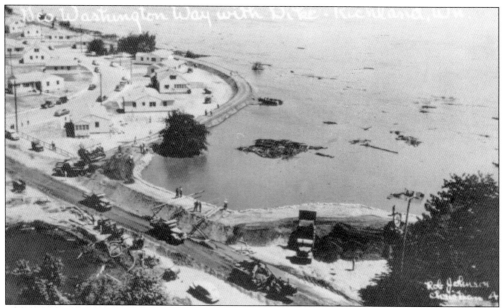

The dike that was built to save Richland was known as "the Miracle Mile," the brainchild of engineer Harry S. Kramer. Trucks worked day and night, for five days, taking gravel from pits north and south of town to build the dike, which was 8 to 10 feet wide at the top and up to 10 feet tall. Thousands of sandbags reinforced the dike while it was being constructed. The dike prevented damage from the business district, the sanitation facility, and the hospital.

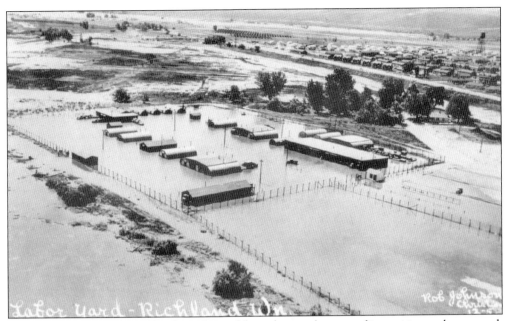

The labor yard in south Richland was doomed from the start because of its position on low ground. This complex was located east of the intersection of George Washington Way and Davenport. Fortunately equipment and furnishings were removed before the facility was inundated.

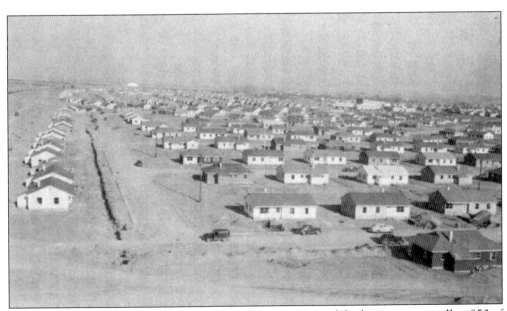

In 1948, construction of 100 ranch houses was begun. Most of the houses were smaller: 950 of them would have 3 bedrooms and only 50 of them would have 4 bedrooms. They were to be located in the area west of Wright Street and south of Van Giesen Avenue. Ground was broken on March 20. The ranch houses shown are along Swift, looking north down Elm Street.

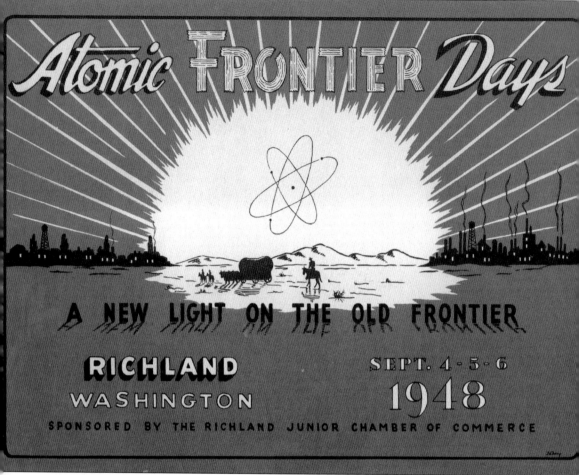

Richland's annual celebration was first called simply "Richland Days." In 1948, the festival was re-named Atomic Frontier Days. The celebration, held September 4, 5, and 6, was marked with a parade, barbecue, and the crowning of the Atomic Frontier Days queen, Barbara Wiltz. This pamphlet documented the program planned for that first celebration. Included in the weekend's events were a bowling tournament, concert, air show, barbecue, and jalopy derby.

This ribbon was made to commemorate the first Atomic Frontier Days in 1948. Several celebrities were on hand for the parade, including Roddy McDowell and Jimmy Wakely. Actress Janice Paige was crowned the Atomic Frontier Days queen. Edmond F. Johnson, 3 years old, won the Atomic baby contest.

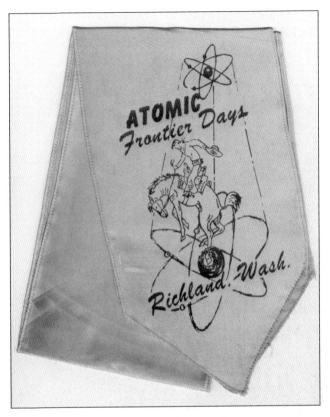

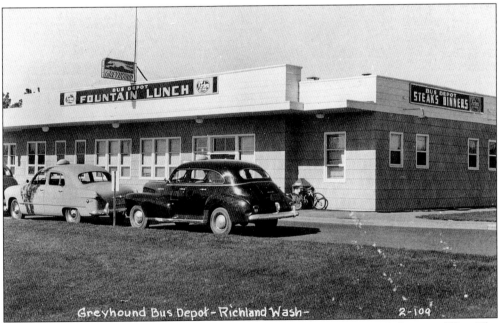

The Greyhound bus depot opened in September 1948 at 500 George Washington Way. The manager was C.E. Colepaert. At the time it cost $5.95 for a bus ticket to Portland, Oregon. Today the Jackpot Gas Station stands where the depot used to be. Richland no longer has a bus station.

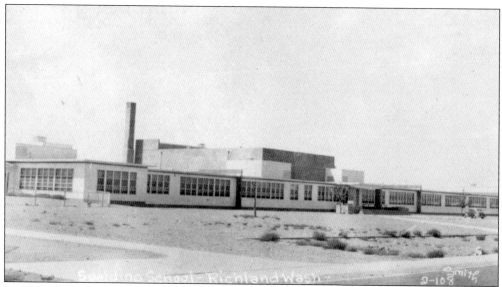

Spalding School opened on October 4, 1948. There were 500 students. Ernest Nicolius was the first principal. The school was closed in 1982 due to safety concerns over the structural soundness of the building.

Richland High School has always promoted a strong music program. The girls in this picture are part of the Mixed Choir, directed by Charles Bird. Pictured, left to right, are: (front row) Bobby Lynn Wilkinson, Joyce Fisher, Jerry Langan, Marian Clark, Audrey Roberts, Mary Lou Stines, and Paula Doctor; (middle row) Marlene Morton, Pat Upson, Alice Daves, and Rosemary Johnson; (back row) Maryline Smith, Nancy Archibald, Ann Clancy, Dorothy Cravens, Barbara Clemmens, and Betty Riedell.

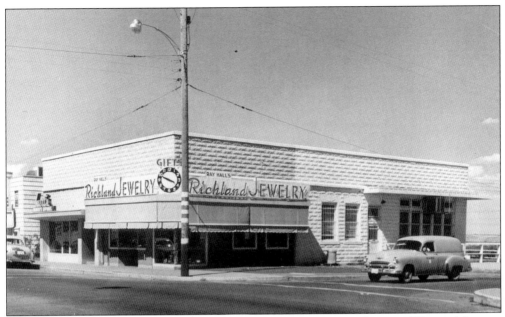

Richland Jewelry opened on the northeast corner of George Washington Way and Lee on October 13, 1948. Besides jewelry, the store also carried sterling silver, glassware, china, and watches. The store offered door prizes at the grand opening. This is the original Amon Building, built in 1906. Jade East Art Gallery later moved into this building. Today, Richland attorney Michael Kozlowski maintains an office in this space.

Richland High School's Girls' League organized various events throughout the year in 1948. They organized the Thanksgiving Formal, the Tolo Dance, and a Dads-and-Daughters Banquet. They also worked as office aides. The Girls' League, left to right, are: (sitting) vice president Sue Dodson, and secretary Loretta Liggett; (back row) treasurer Paula Doctor, president Elizabeth Myers, and teacher Miss Van Note, who served as the league's advisor.

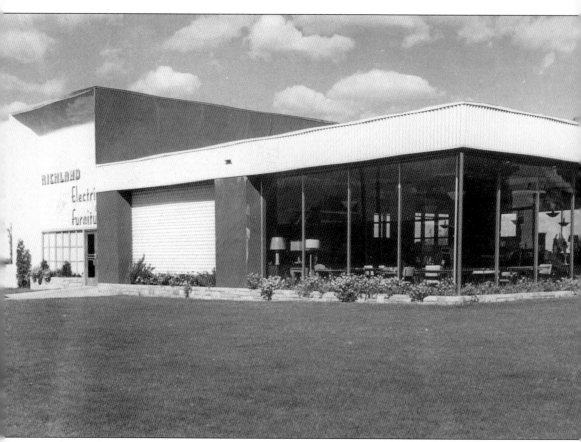

Richland Bell Furniture opened on December 3, 1948, on George Washington Way. Much fanfare was made over its very large 20-foot by 20-foot windows. A year later it moved to its current location, with its main door facing the Parkway and a secondary entrance facing George Washington Way. Today the building looks much the way it did when it was first built. This store was the first privately owned and operated retail store in Richland.

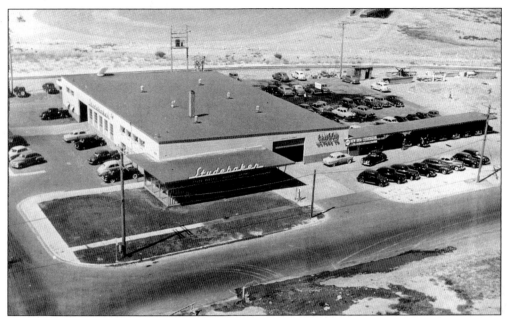

A Studebaker dealership opened on March 15, 1949, located at the northwest corner of Lee Boulevard and Stevens Drive. The business was called Cahoon Motor Company and Jack Cahoon acted as vice president and general manager. The building cost $100,000, a lot of money for those days. Other car dealerships have held the building over the years. Today the Richland School District uses the building as office space.

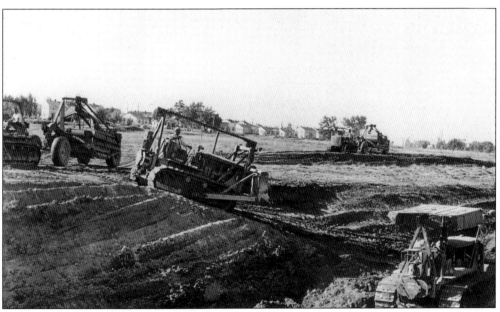

In July 26, 1948, Richland's "master plan" was made public. Commercial facilities and a new business district were planned for an Uptown Shopping Center. This scene shows bulldozers breaking ground for the new commercial district in early 1949, located between Jadwin and George Washington Way to the east and west, respectively, and Symons and Williams, to the north and south, respectively.

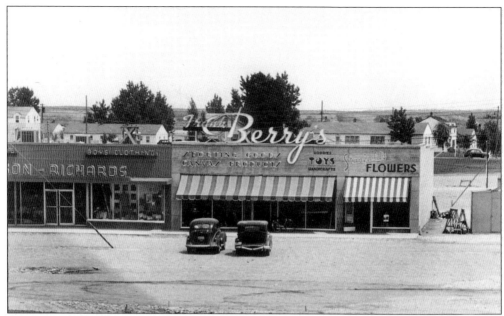

The first store to open in the Uptown Shopping Center was Dawson-Richards, a men's clothing store. The store opened on May 10, 1949, to a crowd of 3,000 people. Next door was Frank Berry's Sporting Goods (later BB&M), which opened May 26, 1949. Berry's started building at the same time as Dawson-Richards, but a carpenter's strike delayed construction. Stanfield's Flowers opened the same day as Berry's. Mr. and Mrs. Ed Stanfield of Kennewick were the owners.

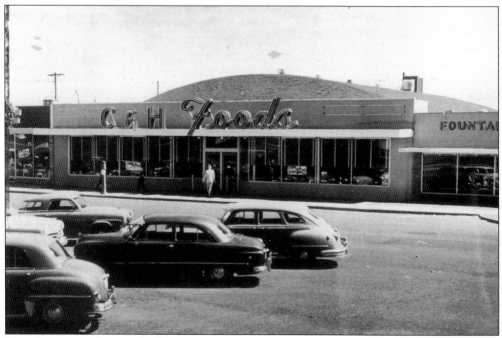

There were two branches of C&H Foods. One was on the northwest corner of Swift and Wright. This was the other store, located at the Uptown Shopping Center on the Jadwin side.

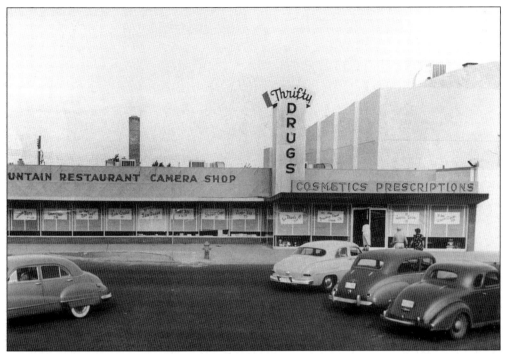

The Thrifty Drug Store moved to the Richland Uptown in 1949. Generations of kids visited the Thrifty Drug Store to buy their penny candy before going to see the movies next door. The building still exists, but the drugstore has been replaced by Dordon's Flowers & Balloons, Desserts by Kelly, Alexanders, and the Emerald of Siam restaurant.

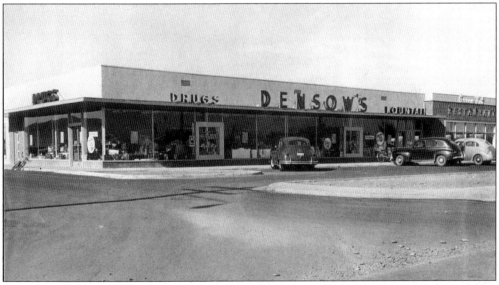

On September 30, 1949, Densow's opened on the corner of Wright Avenue and Duportail. George P. Doran and Evan Lytle were co-managers. Mr. Lytle was popular with his friends and neighbors; one of his acts of charity was to furnish free drugstore and toiletry items to the local convent. He also extended credit to those he knew couldn't pay. The Green Hut restaurant next door, opened in October of 1949, and was a very popular restaurant.

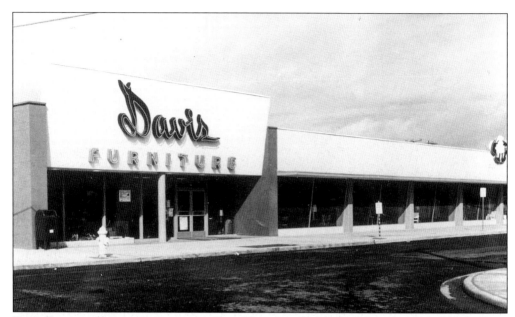

Davis Furniture began construction on June 30 and opened on October 13, 1949. The business occupied 1341 George Washington Way in the Uptown Shopping Center. LeRoy Davis was the general manager. Korten's Music Store opened the same day and occupied the same building. The store carried organs, pianos, and band instruments. Charm Beauty Shop also occupied the Davis building. This building is now occupied by Talk of the Town Hair Design, PSS Rubber Stamps, and Farmer's Insurance. The space once occupied by Korten's stands vacant.

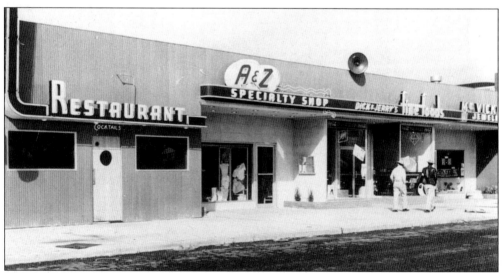

Ernie's Restaurant opened at 1353 George Washington Way in October 1949. Opening shortly afterward was A&Z Specialty Shop, a store that specialized in blouses. Dick & Jerry's Fine Food's opened in Uptown Richland on January 2, 1950. It was owned and operated by Jerry Hutson and Dick Watson. McVicker's Jewelry, managed by Rex E. Ehrhart, opened about the same time as Ernie's and A&Z. Today Ray's Golden Lion Restaurant occupies almost all of the space of the four stores.

The Richland Beauty Salon opened on October 13, 1949. It was located at 715 The Parkway. A regular permanent cost $8.50. A Cold Wave could cost $10 or more.

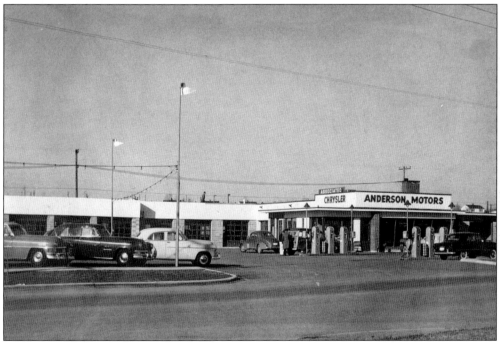

This gas station and car dealership was known as Anderson Motor Company. Located on Stevens Drive, Anderson sold Chrysler, Dodge, and Plymouth automobiles. It was owned and operated by father and son, both known as A.J. Anderson. The store opened on November 26, 1949. Today office buildings occupy the space where Anderson Motor Company once stood.

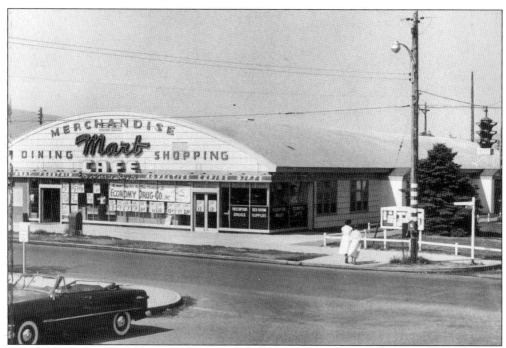

Officially known as the Economy Drug Store, the Mart was located at the southwest corner of Jadwin and Knight in the former cafeteria. The store was remodeled in November 1949 to add a cocktail lounge, cafeteria, and restaurant to the general store. In December of 1959, the store was moved to the corner of Jadwin and Lee and became Payless. In 1969, Payless and Rosauers opened at the corner of Lee and Goethals. Payless still stands, but Rosauers is now home to Richland Suzuki.

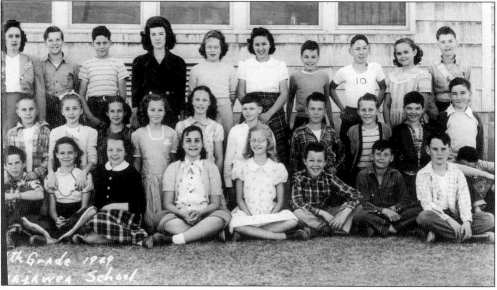

Sacajawea School opened in September of 1944 on the southeast corner of Stevens and Williams. Pictured is the sixth grade class of 1949. Future favorite Richland Bomber science teacher Jim Harbor is pictured fourth from right on the bottom row.

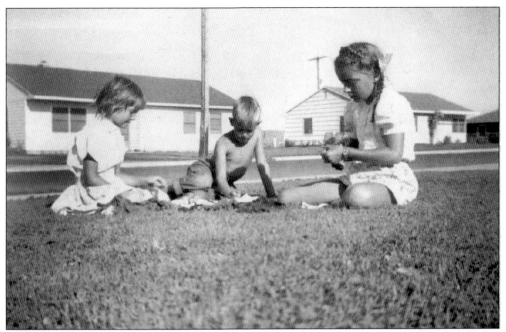

In 1949, (left to right) Patti Jones, Joe Jones, and Mary Marsh enjoy nice summer weather. Their home is located on Birch Street. The Marsh home is to the left and the Jones home is to the right. Like all the early alphabet houses, the homes tend to look alike, especially in the days before trees were planted. The friends are playing with turtles, as Mary usually had pet turtles.

In 1949, the Second Annual Homecoming for Columbia High School was a game against Kennewick. Richland won, 14–12. A victory party was held in the gym afterward. A pep rally and bonfire was held at the field before the game, where a float constructed by the senior class won first prize. There were other floats and cars entered by various school clubs.

The theme was Autumn Serenade at the Thanksgiving Formal of 1949. Couples danced to the music of the Hi-Spotters. In this photo, sophomores Mary Ann Baudendistel, Hugh Hinson, Lou Ann Binns, and Lionel Roberts are on their way to the big dance.

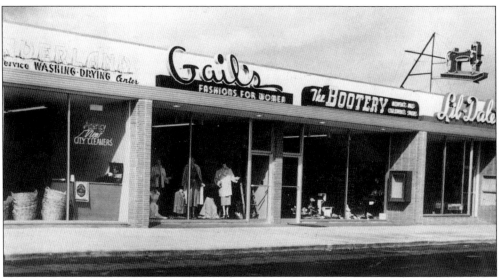

Launderland opened in Uptown Richland at 1375 George Washington Way in early 1950. C.D. Joseph and Hugh Cannon were the managers. Gail's clothing store opened shortly afterward at 1377 George Washington Way. The Bootery opened at 1379 George Washington Way in March of 1950. Lil Dale's, a sewing supply store, opened at 1381 George Washington Way. Today, Amazon Bay, a pet supply store, and Desert Spring Chiropractic Holistic Health Care also rents part of this space.

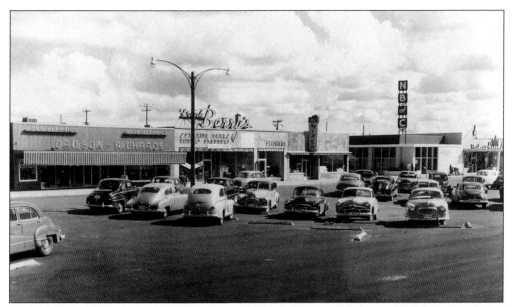

Dawson-Richards and Frank Berry's Sporting Goods Store were soon joined by other stores. The Mixer opened next door on February 18, 1950. It was a combination billiard room and soda fountain. The National Bank of Commerce first opened on June 20, 1949, next to Berry's. In mid-January of 1950, it moved into its permanent location shown here. Parker's Hardware, owned and managed by Willard Parker, carried a complete line of housewares, sporting goods, and garden supplies.

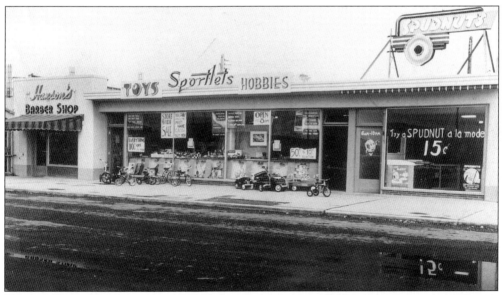

Hanson's Barber Shop opened in 1950. Today, the location is still a hair salon, now named Caesar's Hair Styling. Sportlets opened on June 9, 1949, as a toy and hobby store, originally sharing space with Berry's Sporting Goods. It moved to this location in October of 1949. The Spudnut Shop was originally located in the Richland "Wye" area but moved to its new quarters in uptown Richland on March 5, 1950. It was opened and operated by Jerry Bell and Barlow Ghirardo.

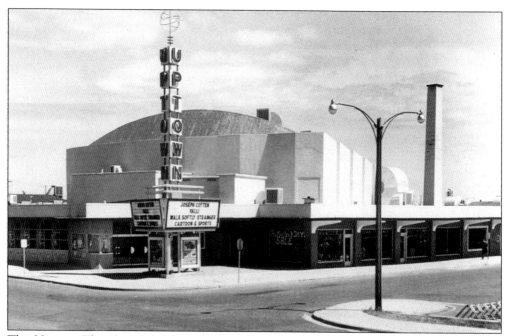

The Uptown Theater was built in the Uptown Shopping Center on the southwest corner. Opening night on October 26, 1950, showed *The Petty Girl* and *Beaver Valley*. This theater is one of the few businesses in the Uptown that has occupied the same space since it opened. Today it is the only movie theater in town.

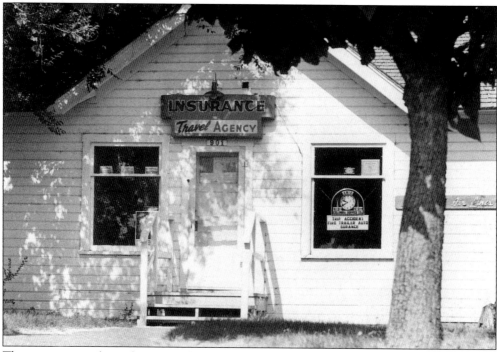

This insurance and travel agency is likely the Randolph Stanley agency, located at 713 George Washington Way. The Gary Scofield State Farm Agency is located in this spot today.

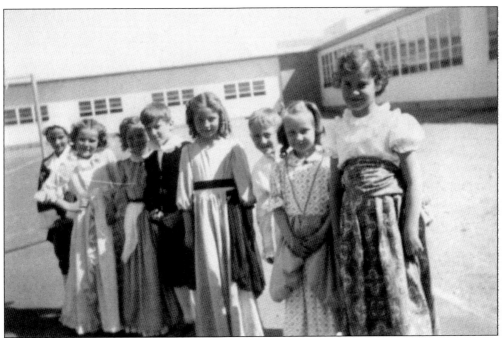

One of the earlier classes at Spalding, these students stand outside the building. Dressed in costume, the students were part of a history class studying the 19th century.

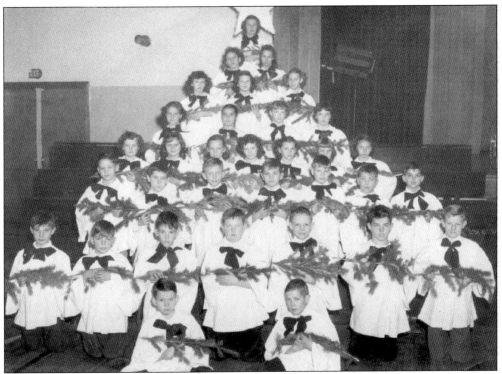

Like many grade schools, Spalding school had a Christmas program in 1951. Pictured is the school choir in their costumes. Note the students are arranged in the shape of a Christmas tree.

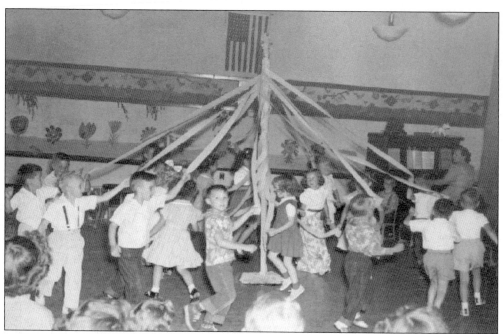

Jefferson Elementary School opened on September 11, 1944. Louise Johnson was the first principal. In 1948, new classrooms, offices, lunchroom, and expanded gymnasium and auditorium were added due to rising numbers of school children. In this 1952 picture, first graders dance around the May Pole, boys on the outside, girls on the inside. Their teacher Mrs. Warren played the piano.

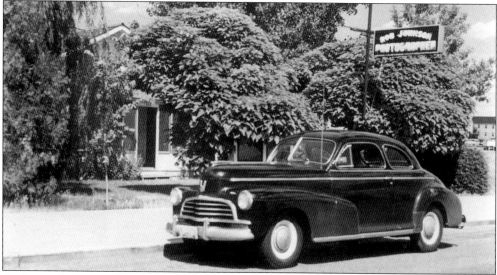

Professional photographer Robley Johnson was a part of Hanford from the beginning. Johnson was responsible for taking official government photos of all of the Hanford Engineer Works properties and projects. He also took hundreds of photos of Richland's progress through the years. It is because of Johnson that so many pictures of Richland's war- and post-war years exist today. Johnson's photo studio was located at 905 George Washington Way. The building has long since vanished from the landscape.

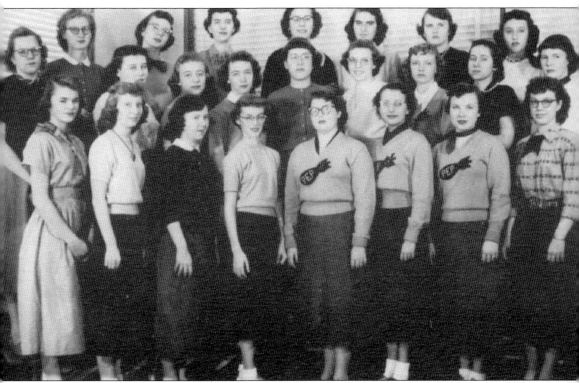

The Tri-Hi-Y girls were part of a social club sponsored by the YMCA. They organized a chili feed and a Thanksgiving feed for a poor families, among other activities. The girls pictured here, from left to right, are: (front row) B. Williams, D. Thompson, N. Loescher, S. Sturgis, D. Trout, G. Henderson, M. Lockart, and D. Davis; (middle row) L. Gilpin, E. Cooke, B. Culverhouse, S. Hummel, L. Hurst, R. Winchester, C. Hughes, J. Bounds, and advisor Miss Spainhower; (back row) J. Richards, J. Ostrum, S. Hall, S. Miner, S. Bowers, M. Allen, and M. Bollen.

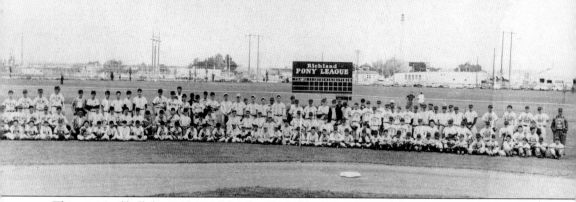

This group of ballplayers formed the first Pony League, organized by Hal Smith Sr. Mr. Smith was the general personnel manager for General Electric. This picture was taken at Columbia Playfield in 1952, and included the members of all teams that were part of the Pony League that year. Campbell's Meat Market was one of the largest sponsors.

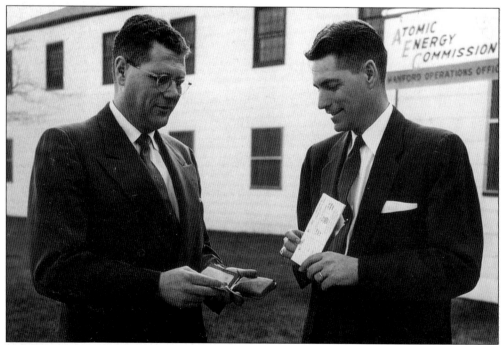

The following year, Hal Smith Sr. was one of the most ardent boosters of his club. Here he is selling Pony League tickets in the Spring of 1953.

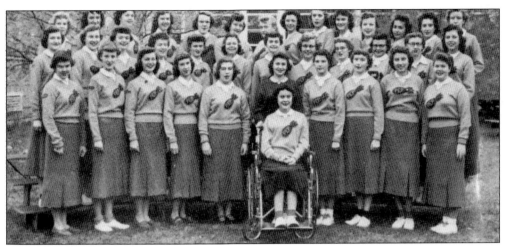

Miss Alice Cone and Mr. John Sharp led the Richland High School Pep Club in 1954. Pictured, from left to right, are: (front row) J. BonDurant, J. Allan, L. Paulsen, J. Geztel, M. Finch, R. Geldner, P. Duffy, D. Card, M. Gulley, G. Grys, and S. Sturgis; (middle row) B. Stevens, C. Pritchard, J. Hoff, C. Staples, B. Russell, D. Dudley, J. Pearson M. Groff, D. Trout, N. Myrick, R. Windchester, and W. Houghton; (back row) C. Williams, J. Cline, N. Wissinger, W. Vance, P. Thomas, G. Craddock, S. Sadler, B. Sullivan, S. Jones, A. Boren, D. Thompson, L. Murphy, F. Smith, and J. Dunn.

These sixth grade students from Spalding are getting ready to go to Forest Camp. The students earned the trip by collecting boxes and boxes of hangers. From left to right, the children are Doug Rathbun, Sandy Shaver, Patti Jones, and an unidentified boy. The 1949 Plymouth belonged to Patti's dad. Teacher Howard Chitty is in the background. The lady between the cars is unknown.

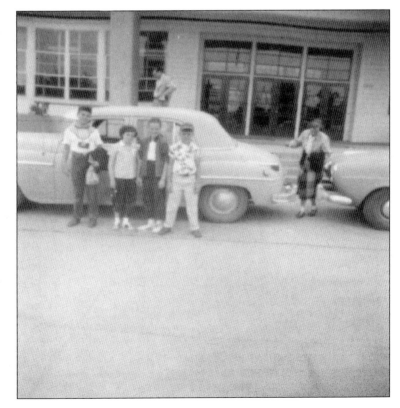

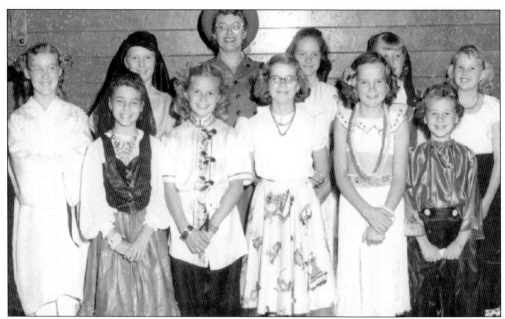

Girl Scout Troop No. 36 had fun studying foreign countries since it gave them a chance to dress up. Pictured, from left to right, are: (front row) unidentified, unidentified, unidentified, Patti Jones, and Barbara Haugen; (back row) Dee Cole, Karen Crownover, unidentified (troop leader), Barbara Barnes, JoAnn Rasmussen, and Carol Shuey.

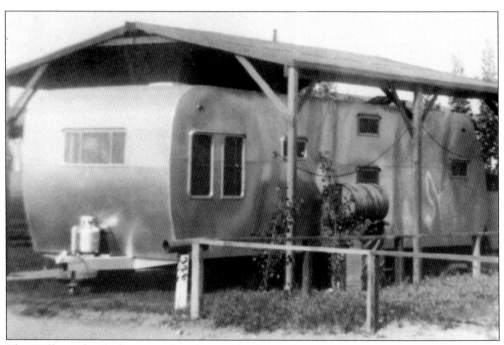

The Williams family first moved to the North Richland trailer park in 1950. They moved into this small trailer home on "I" Street in 1953. At 30 feet long, this trailer was the largest of three homes they had lived in. The trailer park was near the river, providing a play area for the children. There was also a movie theater for entertainment.

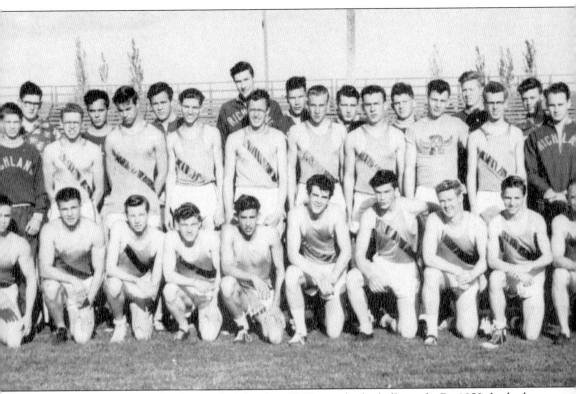

Art Dawald came to Columbia High School in 1947, as a basketball coach. By 1953, he had taken on other sports, such as this track team. The team was especially strong in the running events. Pictured, from left to right, are: (front row) L. Wilson, G. Wilson, D. Green, H. Kenitzer, D. Baxter, P. O'Bryan, C. Scamahorn, D. Riggin, W. Fisher, and H. Morris; (middle row) K. Chubb, J. Corey, D. Gordon, B. Thomas, D. Hoxie, R. Gordon, D. Johnson, D. King, T. Keaton, F. Goodenow, M. Burt, and R. Wells; (back row) B. Witherup, B. Burke, J. Nageley, S. Nageley, W. Moss, K. Burke, J. Jones, T. Neth, J. Clark, and J. Alexander.

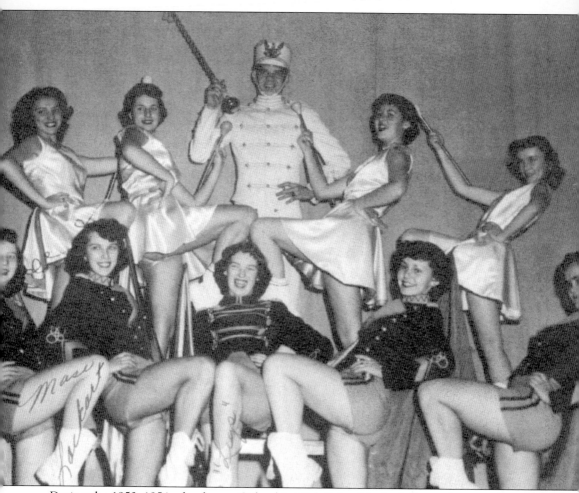

During the 1953–1954 school year, Columbia High School had a full complement of musical programs, including marching band, orchestra, pep band, glee club, and choir. Pictured here, left to right, are the majorettes and flag twirlers that completed the ensemble: (front row) Mazie Lockart, Loretta Ostboe, Mary Warren, R. Rawlins, and Nancy Grow; (back row) Joan Cline, Arlene Glover, Jack Lippold, Sharon Bee, and Deanna Overstreet.

Construction began on April 20, 1954, for Christ the King Catholic School. The school would be the first parochial school in Richland. The school was ready for the next academic year and opened on September 8. It opened with just first, second, and third grade. It would later expand up to eighth grade and add a kindergarten. The school stands in the same location, looking much the same as it did when it was built.

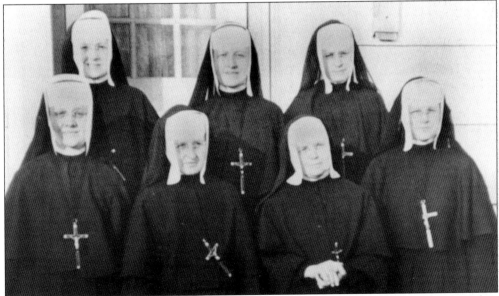

Sisters of the Holy Names came to Christ the King School in 1955. They lived in a convent just beyond the school grounds, built shortly after the school opened. Sister Margaret Jane was one of the principals. Unfortunately, the names of these ladies are lost to history. But they served faithfully and tirelessly until the last sister retired or died in 1985. The convent is now used for various other parish activities.

Though the nation knew the awesome power of atomic weapons of war, it wondered what peaceful uses there could be for atomic power. The "atoms for peace" program explored other ways the power of the atom could be unleashed. The U.S. Post Office issued this First Day Cover to commemorate the efforts to put atomic energy to good use, such as the generation of electricity.

Girls prepare the Richland High School newspaper by looking at newspapers from other schools around the region. Left to right are editor-in-chief Barbara Kramer, Lark Lane, and Virginia Brinkerhoff.

Four
RICHLAND BECOMES A CITY

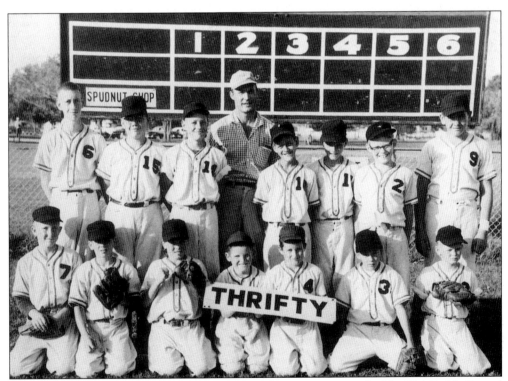

Pictured is one of the first Little League teams. This team was coached by Hal Smith Sr. and played in the 1957 season. Their sponsor was the Thrifty Drug Store.

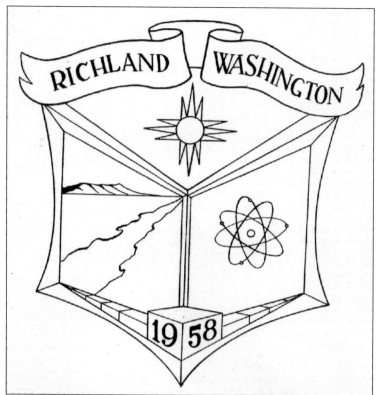

The Richland Seal was adopted in 1958, when Richland re-incorporated after 14 years of government control. The sun, river, and atoms represented the abundant resources of Richland.

The high school graduation of December 10, 1958, was a special one. The city voted to incorporate itself on July 15, 1958. It became official on December 2, with ratification of a city charter. The graduation ceremonies were held at the Columbia High School stadium (popularly known as Bomber Bowl) with various dignitaries on hand. Governor Albert D. Rosellini, U.S. Senator Warren G. Magnuson, Dr. A.B. Greninger, acting general manager of General Electric, and many others celebrated the incorporation of Richland.

Atomic Frontier Days of 1959 was one of the biggest events ever. This year, floats from Milton-Freewater in Oregon, and Prosser, Grandview, Pasco, and Kennewick in Washington participated in the parade. Fire engines from Camp Hanford and Richland also displayed their bright machines in the line-up. The parade was led by the U.S. Army 4th Infantry band and marching units. Another highlight of the weekend was a rock and gem display and an army display of weapons at the Community Center.

Atomic Frontier Days also included many other events besides the parade. There was an obstacle course race and a go-cart track at the Uptown Shopping Center parking lot. There was also a carnival, talent show, fencing exhibition, and a "best beard" contest. There was a golf tournament at the country club and a fireworks display. Behind it all, no one could forget the sponsorship of General Electric, general Hanford site contractor, who sent this neat float down George Washington Way in the parade.

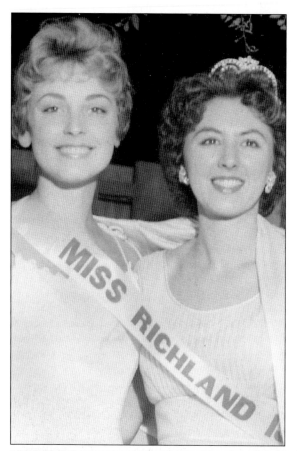

Sharon Tate (left) was crowned Miss Richland at the annual Atomic Frontier Days celebration in August, 1959. In this picture, Sharon is with Patti Stewart, to whom she gave her crown because she couldn't serve her term. Her father's military assignment would be taking them to Italy. Upon graduation from high school, Sharon went into acting and starred in a number of movies, including *Valley of the Dolls*. Sadly, Sharon Tate was murdered by the Charles Manson gang on August 9, 1969.

On September 30, 1959, Ronald Reagan visited Hanford. At the time, Reagan had not yet embarked upon his political career. He was the supervisor and frequent star of the "General Electric Theater." Reagan took a two-day tour of the area, in which he met with local officials and attended several speaking engagements. He appeared on the news with six panelists to discuss the local business climate. He spoke at the GE Supervisor's father-daughter banquet and the Camp Hanford Officer's Club.

The new city hall was dedicated on December 12, 1959. These men comprise the first elected advisory council. All functions, such as fire, police, and city clerk were operational at the time of the dedication. One of their first actions was to pass Resolution 70, which requested support from Congress to erect a federal building.

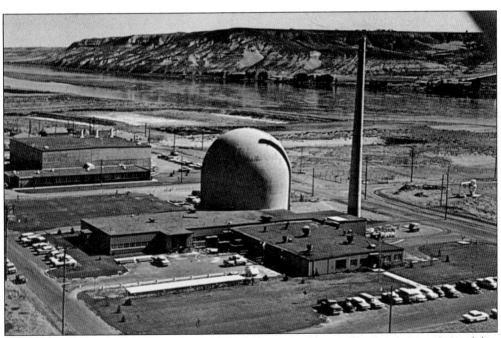

During this time, the government was looking for non-war uses of atomic energy. Part of that program meant that different uranium fuels would need to be tested. This plant, called the Plutonium Recycle Test Reactor, was built in the 300 Area to accomplish this mission. The plant went critical on November 21, 1960. Over the next several years, fuels were tested and power was generated. The reactor was closed in 1969.

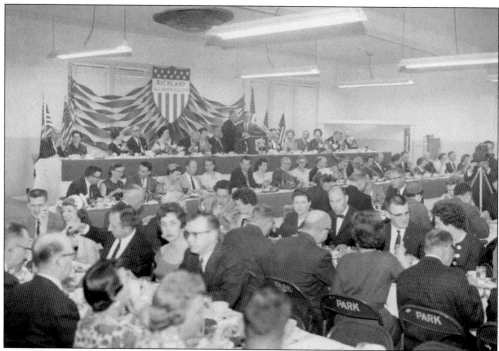

In 1961, Richland was selected as an All America City. The award was bestowed by Look Magazine and the National Municipal League in April. Richland was 1 of 11 communities chosen from over 100 entries. Richland was recognized particularly for its efforts to establish self-government and incorporate itself as a First Class City.

This sign, commemorating Richland's status as an All America City, was erected on the outskirts of town. Pictured with the sign are Sam Volpentest, city manager Murray Fuller, and mayor Joyce Kelley.

Five
THE PRIDE OF RICHLAND

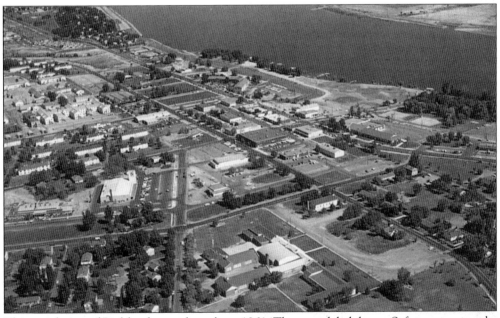

This aerial view of Richland was taken about 1961. The remodeled, larger Safeway store can be seen in the center right. In top center, the 703 building has not yet been torn down to make room for the federal building. Lewis and Clark Elementary School stands in lower center.

The Imperial 400 Motel stood at 515 George Washington Way, in 1962, one of the first motels in Richland. In 1989, Econolodge bought the Imperial. Between 1994 and 2001, the Vagabond Inn housed travelers and visitors to Richland. Today the Economy Inn occupies the same buildings as the original Imperial 400 Motel. It doesn't look much different from the time the Imperial was built.

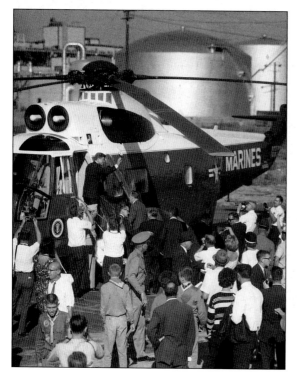

On, September 23, President John F. Kennedy came to Hanford for the ground-breaking ceremony to begin the construction of the 100-N Reactor, which could produce steam for generating electricity, as well as produce plutonium. It would be the world's largest electrical generating plant, capable of producing 800,000 kilowatts of electricity. Thousands were on hand to attend the dedication at the reactor site. In this picture, President Kennedy boards the presidential helicopter as he leaves N Area.

As usual, Homecoming at Columbia High produced a number of activities, including the Homecoming Dance on Saturday night. The 1963 Homecoming Royalty included, at top, Queen Susan Knox. Second row from top, left to right, are Senior Princesses Andi Rowe and Connie Hanson. Third Row, left to right, are Junior Princesses April Snoeberger and Susie Vandenberg. Bottom row, left to right, are Sophomore Princesses Franni Brown and Carole Fatur.

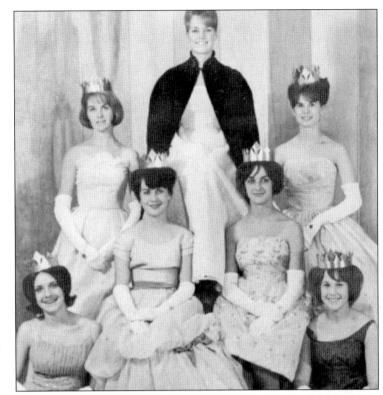

The Future Homemakers of America girls learned everything from cooking to sewing to proper etiquette. These classmates posing in the cooking area with several commonly used utensils, from left to right, are D. Bennett, P. Crownover, J. Bloodworth, J. Shuey, M. Greer, S. Steichen, S. Ray, and B. McMakin.

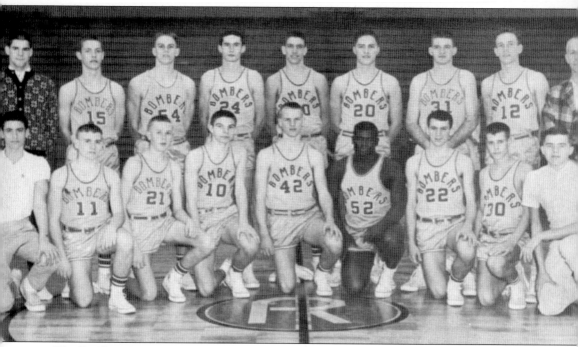

The Bomber's Junior Varsity had an outstanding year in 1964. Coach Ray Juricich led the team to a 16 and 1 season, their only loss coming to the Wapato Wolves. The team, from left to right, is: (front row) Marc Franco, Chris Boulange, Ron Anderson, Phil Neil, Doug Strasser, Fred Milton, Denny Duncan, Chuck Knoeber, and Frank Bolson; (back row) Walt Sommers, Dave Sonderland, Bob McClellan, Mike Grinnell, Kurt Crownover, John Allen, Mike Coyne, Ken Fortune, and Coach Ray Juricich. Sophomore Phil Neil would return to Richland to coach some winning teams of his own.

For years, individual pictures of the sophomores were not taken. Even odder, pictures were not taken in alphabetical order, but according to what class the students were in. Then the students were further divided into girls and boys. These girls are from first period of 1963–1964. From left to right, they are: (front row) Maureen Barber, Nilea Bean, Carolyn Benoliel, Shirley Briski, Ann Coffman, Jeannine Erickson, Cheryl Evans, Carol Forsythe, Bonnie Foster, Linnea Gates, Cathy Geier, and Susan Gulley; (second row) Glenna Hammer, Elizabeth Hetrick, Sarah Hickam, Marvee Huxel, Delsa Jones, Mattice Jones, Virginia Morris, Dottie Nelson, Betti Okura, Cheryl Pollard, and Jacqueline Porter; (third row) Leta Ramerman, Kathy Rathjen, Sue Ray, Kathleen Reinig, Mary Reynolds, Caroline Rodgers, Joanne Ruppert, Marian Russell, Pam Rust, Carole Saari, Bettina Shellman, and Becky Skarshaug; (back row) Christine Simek, Ann Skidmore, Trudy Spilman, Gloria Stewart, Linda Stump, and Linda Wersen.

In 1964, Coach Art Dawald was voted the favorite teacher. He was also known as one of the top high school coaches in the state. Up to this point in his career, he had taken 13 teams to the state tournament, winning in 1958. When not coaching, Mr. Dawald taught social studies. Later the boys gym would be named for him.

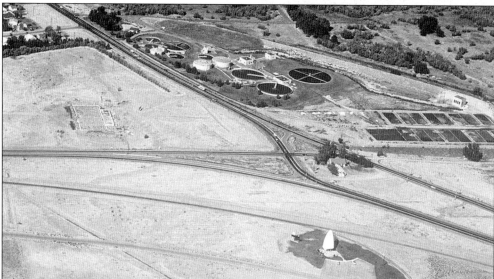

The city's sewage treatment facility, affectionately known as the Rose Bowl, was built in 1943, at the southern edge of town. It was moved next to ACME Concrete in 1986. The Coordinate Club was built in September 1943, as a night club for employees and their families; a separate club called the Castle Club was restricted to government employees. The white triangular structure is an office building that was occupied by Tru-Stone Concrete. It was built in 1962. When it was moved in 1982, it was no longer occupied.

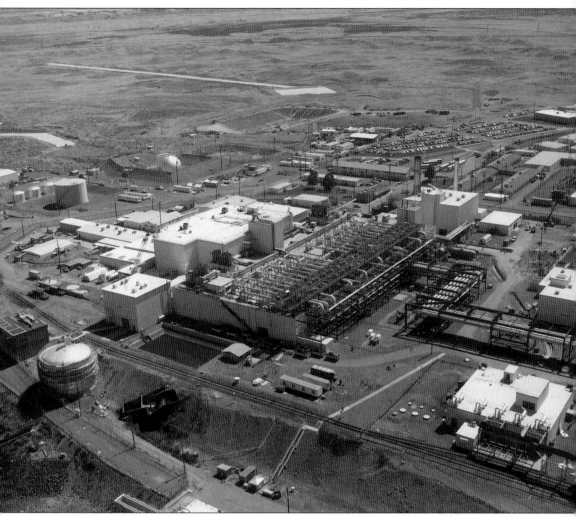

N Reactor was known as a dual-purpose reactor. This meant that while producing weapons-grade plutonium, it was also capable of producing electricity with steam. It was the ninth reactor built, and like the others, did not have a containment dome. It had several innovations in its design, one of which was that it recirculated its cooling water rather than discharging it and its contaminants to the river. It operated from 1964 through December of 1986, when concerns after the Chernobyl accident and other equipment problems led to its permanent closure. Permanent decontamination and decommissioning was begun in 1994.

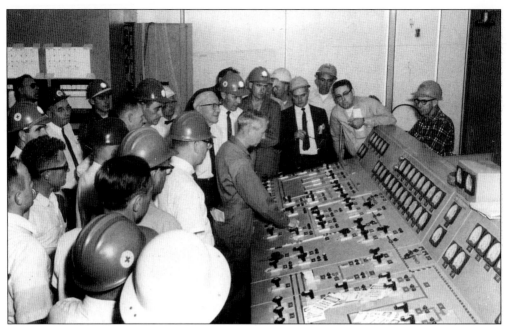

West Mattis, a control room operator, got the honor of flipping the switch at the Washington Public Power Supply System Hanford Generation Plant. At 5:52 p.m. on April 9, 1966, Mattis fed the first nuclear power received from the N Reactor into the Bonneville Power Administration system. Officials from WPPSS, General Electric, and the Atomic Energy Commission were on hand to witness the test, which was called a complete success by Owen Hurd, WPPSS managing director. Full power was achieved by August.

Simply called the Federal Building, construction on this building on Jadwin and Knight Street began in 1963. Construction was completed in August 1965. U.S. Senators Warren Magnuson and Henry "Scoop" Jackson were on hand for the dedication that November. As it always has, the building houses the offices of federal officials that govern operations at the Hanford Site. Today the building still stands, changed very little from the time it was built. The building also contains the Richland Post Office, a U.S. District Court, and an FBI office.

Zip's Drive-In has long been a favorite hangout for teens. The Richland Zip's, owned and operated by Bob and Mary McDonald from 1961 to 1978, was located on Lee Boulevard, where it still stands today. The picture shows a typical Friday night in 1967.

Dr. Glenn Seaborg, AEC Chairman, and Major General Leslie Groves attend the celebration of the 25th anniversary of Hanford, and 10th anniversary of Richland in 1968. This picture was taken at the 100-B Reactor. A park in north Richland was named for General Groves.

A mushroom cloud has been printed on everything from Columbia High School annuals to class rings since the fall of 1945. About 1972, the letter "R" was added to the mushroom cloud when Coach J.D. Covington saw a student doodle and liked it. He had the emblem stenciled on football helmets and uniforms. Ever since then, the "R" with the mushroom cloud has symbolized Columbia High School. After some controversy in the late 1980s, school officials put the matter to the student body for a vote. Approximately 90 percent of the students voted to let the symbol continue to represent the high school.

Washington's governor Dixie Lee Ray was the first female governor. In this 1973 picture, she is pictured in the lobby of the Federal Building in Richland. Governor Ray was always a staunch advocate of progress and especially nuclear-powered electricity. She definitely had her own style though—she never went anywhere without her two pet dogs. She was also the original "mom in tennis shoes" (as future senator Patty Murray would bill herself), wearing casual clothes and knee socks with walking shoes.

Decades passed before Hanford High School was reborn in north Richland. When the school opened in 1972, it was an experimental arrangement that detractors said would never work. The difference? The school would house kindergartners through 12-graders, though it did not have a senior class its first year. This courtyard area in this picture is on the south side of the campus, facing Hanford Street.

The Sophomore Class Council looked out for the interests of the Class of 1976. Pictured, from left to right, are Nina Maffeo, treasurer; Sue McKenna, vice president; Joanne Dunn, secretary; Becky McCord, president; and Luanne Spanner, activities coordinator.

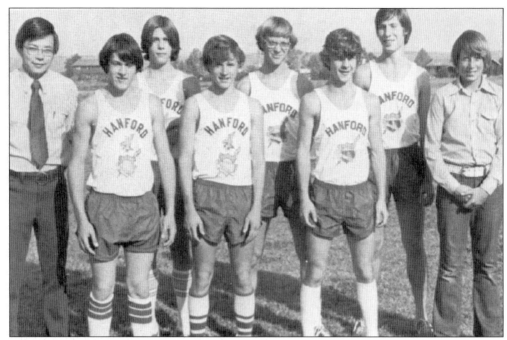

It seems like Richland commuters have been passing high school cross-country runners on their way home from work for many years. In fact it has only been since 1973, when Hanford High School runners began using the mostly empty stretches of the north end of George Washington Way as their practice grounds. In 1973, the Falcons finished 5–4, which tied them for second in their district. Pictured, from left to right, are Coach George Shen, Doug Johnson, Steve Skinner, Bruce Dobbs, Gary Galbraith, Mike McGough, Greg Kiser, and manager John Westerman.

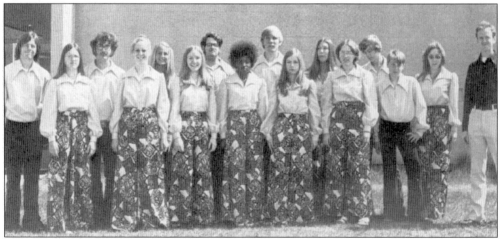

Hanford High had a very talented swing choir that placed Second in the AA division at the University of Idaho Jazz Festival. They also performed at Expo '74 in Spokane. The choir, from left to right, was: (front row) Michelle Trego, Cathy Marzyck, Bonnie Green, Evelyn Bullock, Christie Perkins, Linda Burke, and Rick Dunham; (back row) Hugo Espanza, Joe Hampton, Debbie Van Raper, Eric Richman, Mike Wegner, Susan King, Mike Armstrong, Gail Morris, and teacher Randy Poff.

The yearbook staff started a tradition the previous year with putting out a top notch publication. Their staff advisor was, and still is, Peggy Painter. Pictured from top to bottom, left to right, the staff is: Paul LaMor, Marc Garland, Tine Larsen, Phil Kottwitz, Randy Walli, Sid Wakeham, Christy Perkins, Lori Nelson, Kathy Heald, Randy Otterholt, Rob Marshall, Rob Worcester, Shelly Larrick, Carol Bohinger, Kathy Rogers, Mrs. Painter, Pam Simpson, Lance Richman, Laine Simpson, JoAnn Dunn, Cindy Grush, Bryan Nelson, Vanessa Soares, Paul Wood, Calvin Dudney, Diane Nelson, Jerry Purtell, and (on the fold of the page) Kathy Dewitt.

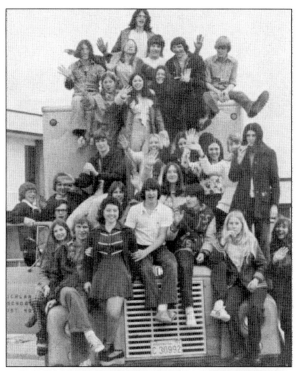

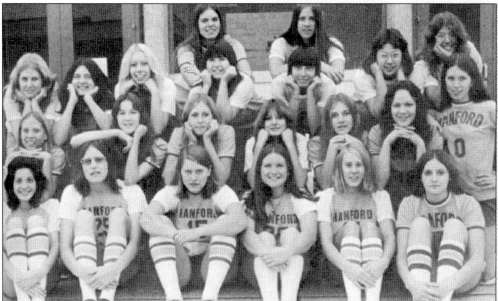

New in 1974 was a Hanford High girls volleyball team. The girls, from left to right, are: (front row) Carole Sanchez, Jill Greenfield, Linnea Preston, Joan McCaffrey, Cheri Lust, and Melanie Pugh; (second row) Cheryl Niemuth, Kim Fancher, Lynn Sauressig, Kelly Percechtel, Illona Chapin, Valerie Hale, and Robin Martini; (third row) Kristi Leaf, Holly Nesseth, Shellie Larrick, Linda Livingston, Carol Fox, Barb Knecht, and Kalleen Reeder; (back row) Betty Zaloudec and Lenore Price. Also on the team, but not pictured, were Vanessa Soares, Laura Dunbar, and Jan Lorenzen.

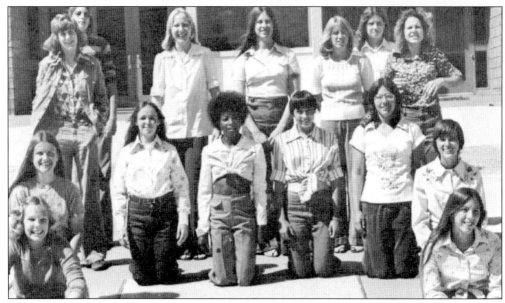

The track team expanded enough in Hanford High's second year to form a girls team. They were coached by Mrs. Anderson and Mrs. Renea. Pictured, from left to right, are: Laura Dunbar, Joan McCaffrey, Sue Mathis, Jill Greenfield, Denise Kelly, Evelyn Bullock, Carol Fox, Barb Knect, Cheri Massey, Lenore Price, Jan Lorenzen (glasses), Brenda White, Shannon Smelser, Kristi Estey, and Debbie Larson. Also on the team, but not pictured, were Colleen Peterson and Barb Trojan.

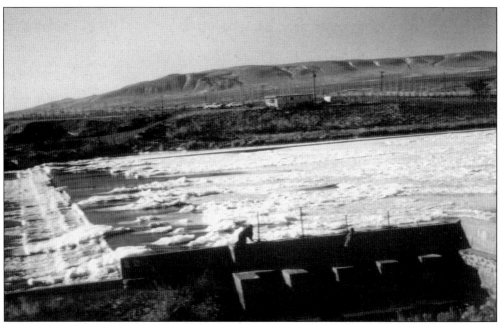

Richland isn't known for its cold or snowy winters. But every once in a while a particularly bitter winter comes along. This picture, taken approximately 1978, shows the ice on the Yakima River near Horn Rapids Dam. The ice was just starting to break up on this clear but crisp day.

In 1979, the Richland Bombers once again won the state championship in basketball. Coached by Phil Neil, the team lost its first non-conference game of the year, before going on to win the next 25 games in a row, to capture the state title. The year would see one of the highest point margins ever scored by the Bombers, 112–39 against Walla Walla. The team, from left to right, is: (front row) Randy Marcum, Steve Chalcraft, Larry Davis, and Brian Kissinger; (second row) Ted Engel, Brian Kellerman, Dennis Soldat, Mark Hoke, Jeff Phillips, and Bob Kennedy.

The Lady Bombers were no slouches in 1979. The women had a 12–4 record in the Big Nine Conference, though this record only netted the women a third place finish. Pictured, left to right, are: (front row) Michelle Sevigny, Debbie Winston, Terri Schwisow, Chris Loss, and Linda Coleman; (back row) Shelly Hilty, Shari Devoir, Teresa Willard, Beth Willard, and Shannon Hogan. Sisters Teresa and Beth Willard anchored the offense with most rebounds and highest average, respectively.

The Richland Bombers softball team of 1980 got off to a slow start. They ended up with a not too glamorous 9–7 record. But Coach Bob Elsensohn kept them in the game with good defense and hitting. The team members, from left to right, are: (front row) Lori Dibber, Kim Winegardner, Lori Mashburn, Jamie Wlulff, Kris Kaiser, and Lori Emery; (back row) Coach Elsensohn, Paula Alley, Michelle Prindeville, Brenda Church, Sally Hansen, Teri Williamson, and Robin Rose.

Each high school yearbook has a full-time staff that works year round to produce a wonderful book of memories. The 1981 yearbook was produced, from left to right, by: (front row) Dawna Brooks, Debbie Moore, Jon Mulligan, and Sid Spence; (second row) Ken Gaugush, Amy Rake, Pam Bennett, Stace Backstrom, Lori Raekes (glasses), and Suzanne Baird; (back row) Monica Colleran, Doug Davis, Steve Schmidt, John Lawrence, Cheryl McIntosh, Curt Luttrell, and Debbie Sharp.

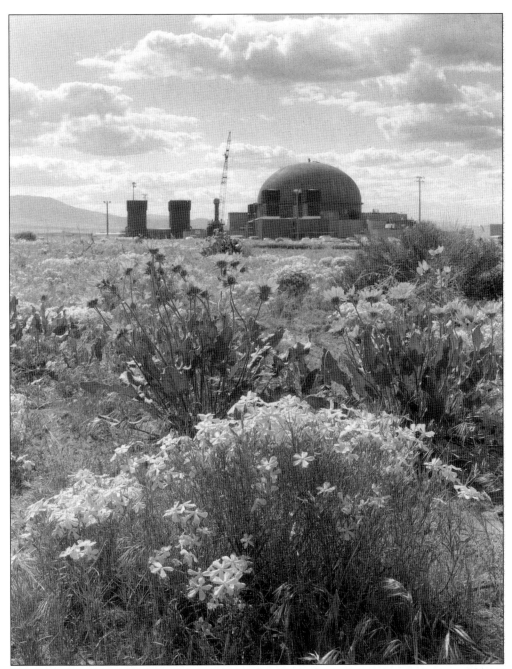

The Fast Flux Test Facility is a state of the art breeder reactor. A breeder reactor is capable of producing its own energy, thus becoming self-sustaining. Hanford's FFTF first came on line in December of 1980, initially to test different types of nuclear fuel and reactor materials. It is also capable of producing tritium, an element used as an accelerant in nuclear bombs. The reactor can also test and isolate various radioactive isotopes, many of which have practical use in treatment of various diseases. This picture was taken shortly after the reactor first came on line. Two serious wildfires in 1984 and 2000 have destroyed most of the wildflowers around the plant, but the reactor buildings themselves were untouched.

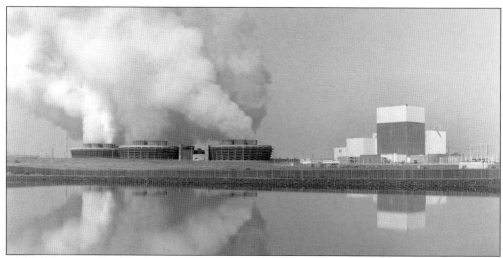

Washington Public Power Supply System has been in the business of producing electrical power since it opened the Hanford Generating Project in 1966, to provide electricity from steam produced at N Reactor. In 1984, Washington Nuclear Plant–2 (WNP-2) sent its first electricity into the Bonneville Power Administration's electrical grid. Two other plants were built nearby, but never finished. This plant, managed by Energy Northwest, still operates today, sending approximately 1,200 megawatts into the power supply. The visible plumes are not contaminants but harmless steam escaping from the plant's cooling towers.

It seems like forever, but the annual Sausage Fest (originally called Oktoberfest) has only been a part of Richland since 1975. Built around a German theme, the festival, held on the grounds of Christ the King School, is a popular autumn celebration. This large crowd gathered at the 1983 festival to watch various outdoor performers. Everyone from local bagpipers to a children's tumbling class to folk singers perform on a volunteer basis. The parachute has been used since the first festival to provide shade.

Part of the "fall classic" is a variety of kid's games, similar to booths at a carnival. While the upper parking lot hosts the entertainment and food booths, the lower parking lot is packed with kids playing their favorite games and winning prizes. The Duck Pond is one of the favorites and usually has a crowd gathered to play.

Bomber Bowl was built shortly after construction of the new high school. But it wasn't until 1980 that the stadium got a huge face lift when the track was resurfaced and a concrete stadium and snack stand were built. The previously "larger" bleachers were then relegated to the visiting team. After that, the stadium became known as Fran Rish Stadium, after a successful coach and athletic director. This graduation ceremony of 1983 was one of the first to be held in the new stadium, under beautiful June weather.

In September of 1990, the first ever Tri-City Grand Prix was held at the Richland Airport. The race was part of the Northwest International Conference of Sport Car Clubs. There were 280 racers competing in several classes. The course consisted of a 1.9-mile track with ten turns, some of them at 90-degree angles. This car was one of many "in the pits" being tuned up before the race. Three local racers also competed in the contest, but unfortunately didn't place. The crowd was also entertained by a bevy of skydivers.

The Tri-Cities area is not really known for severe winters. But during the winter of 1992–1993, the average high temperature for December, January, and February was 28.5 degrees F, 5.1 degrees F below normal. Record lows that year reached 3, 9, and 11 degrees Fahrenheit in February. The area also saw the most snow on record. The previous record in the winter of 1915–1916 was 43.6 inches of snow; in 1992–1993 the snow reached 56.1 inches! After the first snowfall it seemed as if snow never left the ground all the way through early March when the last snow came. Here in Howard Amon Park, deep snow still covers the grounds, virtually untouched even by animals or birds.

In 1993, the Tri-Cities (Richland, Pasco, and Kennewick) celebrated the 50th anniversary of the Hanford project. The year-long celebration brought back many memories for old-timers. This special logo was designed to exemplify the meaning of the celebration.

In 1993, Richland High School seniors left behind a very special legacy. Remembering the sacrifices of war-time, they looked back to 1944, when Hanford workers contributed a day's pay to donate a B-17 bomber to the war in Europe. Artist Pablo Soto was commissioned to paint this 20-foot by 112-foot mural, permanently mounted on the north exterior wall of the Art Dawald Gymnasium. A special finish was applied to the mural to protect it from vandals.

Part of the 50th anniversary celebration included getting kids interested in the history of Richland. This special coloring book was designed completely by local artists and volunteers. The coloring books were distributed free to Richland elementary schools.

When workers come to Richland they come to stay. These service pins represent some of the many contractors that have worked at the Hanford project over the years. Contractors may come and go, but the workers remain loyal to the project, the protection of the community, and the public in general.

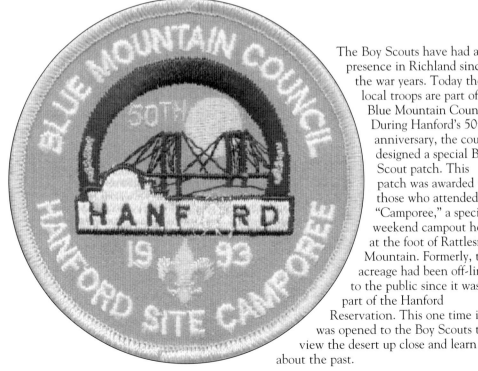

The Boy Scouts have had a presence in Richland since the war years. Today the local troops are part of the Blue Mountain Council. During Hanford's 50th anniversary, the council designed a special Boy Scout patch. This patch was awarded to those who attended the "Camporee," a special weekend campout held at the foot of Rattlesnake Mountain. Formerly, this acreage had been off-limits to the public since it was part of the Hanford Reservation. This one time it was opened to the Boy Scouts to view the desert up close and learn about the past.

113

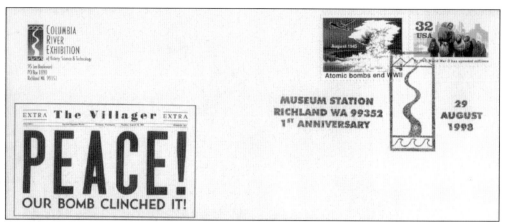

In 1994 the postal service was considering issuing a stamp to commemorate the quick end to World War II by use of the atomic bomb. But protest by the Japanese government and intervention by the Clinton Administration led to the withdrawal of the planned stamp. Ironically, the announcement to rescind the stamp was made on Pearl Harbor Day. Instead of the planned stamp, the post office created a "poster stamp," so that the sacrifices of previous generations could still be honored.

Affectionately known as "The Fingernail," this building was once an office building at the south end of town. During construction of the new highway, the building had to be moved. Rather than destroy it, city fathers preserved The Fingernail at Howard Amon Park. It is now used for outdoor concerts and performances. In this picture taken in 1994, "Men in the Making," a regional group, performs "oldies" rock'n'roll for park visitors. Afterward, everyone was treated to a fantastic Fourth of July fireworks show.

This Boy Scout ceremony took place at the new Sacajawea School in north Richland, in 1995. The ceremony is known as the "Arrow of Light" ceremony, in which a boy "graduates" from Cub Scout to Boy Scout. The placing of the kerchiefs signifies entry into the boy's new troop.

The Environmental Molecular Sciences Laboratories is a state-of-the-art laboratory dedicated in October 1996. Its official name includes the name of William R. Wiley, the Pacific Northwest National Laboratory director who first conceived the idea of such a laboratory and who ultimately brought about its fruition. Open for business in October 1997, the facility studies how environmental hazards affect plants and animals as well as how to safely stabilize and dispose of such hazards.

Hanford contractors have always been strong supporters of various charitable organizations and frequently participate in fundraisers. In this 1997 picture, employees sponsored a pancake breakfast. Labor and supplies were donated so that the money collected could be given to the March of Dimes.

Richland is home to a special training facility with the unwieldy name of "Hazardous Materials Management and Emergency Response" center. Set on 120 acres, the HAMMER facility provides training for workers that handle and ship hazardous materials and who are called upon to clean up spills. The center is especially proud of its firefighter-training program: fire departments from all over the world have come to the HAMMER for training. The center opened on September 24, 1997. It was later named after Sam Volpentest, long-time community leader and proponent of the center.

The graduating class of 1997 contracted with Evergreen Aviation Educational Center in McMinnville, Oregon, to fly a B-17 bomber during commencement exercises. A day before graduation, the flight was threatened by budgetary problems. The plane was finally on its way and landed at Richland airport. Students posed for a picture and a large crowd was on hand to a see the B-17G up close. An hour and a half before flight, a mechanical problem threatened to ground the plane, but mechanics fixed it in time for the overflight of the graduating ceremonies.

The "Miracle Mile" of 1948, would ensure that no flood would ever again cause the disastrous consequences of that year. But occasionally there are still high water years that cause some flooding in the low areas. In June of 1997, record snowfall in the Columbia watershed and unusually warm weather and heavy rains led to high water in Richland. The crest peaked on June 12, approximately two feet above flood stage. There was little damage but this road was blocked and some docks were closed.

Columbia Point Golf Course, a world-class 18-hole course, was completed in 1997 after expanding the original Sham-Na-Pum links. The new course fills space once occupied by the sewage treatment plant. The project cost approximately $7 million, and is managed by Denver-based Premier Golf International. A temporary mobile clubhouse was used at its grand opening on September 14, 1997.

To celebrate the new millennium, Richland Bombers past and present decided to have a reunion for all years of graduates. Led by the Class of '62, the celebration became known as the R2K Reunion. Held in June of 2000, the events were planned to coincide with the annual Cool Desert Nights festival, an event highlighted by a classic car show. Here classic cars drive down George Washington Way, appreciated by Bombers of all ages.

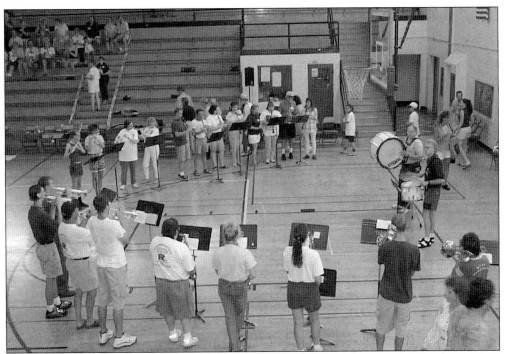

Past members of the high school pep band were on hand to play the Bomber Fight Song and other tunes for the reunion. Here the band members practice the old tunes.

Basketball players of past teams bravely dared to play "one more time." Enough players donated their time that four full teams could be fielded. Two games were played, with players of two different general age groups giving stellar performances. Here, the gold team shoots for a free throw. The bomber pep band cheered them on.

Richland Bombers returned to the high school cafeteria to enjoy one of the highlights of the reunion—a chili feed. Chili and cinnamon rolls have long been served for "hot lunch" to high school students. The original recipes were recreated to serve a large crowd in the lunchroom.

Part of the reunion activities included an old-fashioned sock hop, with vintage rock 'n' roll tunes. The green and gold are prominently displayed in the girl's gym with "antique" '45's hanging down. The sock hop was well-attended and was one of the most popular events of the reunion.

Richland Bombers Michael Peterson and Maren Smythe share a hug at the reunion. Peterson, from the Class of '74, is enjoying success as a country singer. Smythe is responsible for ensuring classes of past and present stay in touch with an extensive Internet site (http://allbombers.tripod.com) and a daily newsletter.

Higher education has been available to Richland residents through an extension campus in North Richland since the early 1970s. From a small campus offering courses from several northwest colleges, Richland now boasts a full branch campus of Washington State University. The campus caters to non-traditional students, offering a large variety of curricula through night classes and correspondence courses. Bachelor's degrees can be obtained entirely from the branch campus.

Hemmed in by the Hanford Site to the north, the Columbia River to the east, and the Yakima to the west and south, Richland had little room for expansion. But after annexation of Benton County property south of the Yakima River, Richland began expanding the Meadowsprings development area. Today this is one of the fastest growing areas of Richland.

In 2001, this new Mormon temple was built on the west end of Gage Avenue, south of the Yakima River. It won't be long before the empty space around the new church is filled with new homes. Just in the few short months since this photo was taken in early 2002 several new foundations have been laid.

Organizers thought the 2001 Sausage Fest might be in jeopardy because it was scheduled just 10 days after the September 11 terrorist attacks in New York, Pennsylvania, and Washington D.C. Instead, the need for camaraderie and solidarity was intensified as people gathered at the festival in record numbers. On the outdoor stage, these Highland Dancers entertained a capacity crowd.

Though the Sausage Fest is typically a German theme, displaying the colors was evident everywhere. These volunteers led the crowd in several patriotic songs. The Star Spangled Banner meant something extra this year, and there were a few moist eyes in the crowd.

The Atomic Ducks Diving Club has been part of the Tri-Cities since 1960. Since their inception members have dived the most popular spots in the world. In this picture, divers stay close to home, as they dive at Howard Amon Park. Like many other "nuts," these men and women take to the water on January 1, 2002, for their annual Polar Bear Dive. At this time of the year the Columbia River averages 40 to 45 degrees.

In February 1945, the Hanford School was closed and all students transferred to the Richland school. In January 1946, bids were taken to dismantle the old Hanford town site. The concrete shell of the old high school is the only physical remains of the old town.

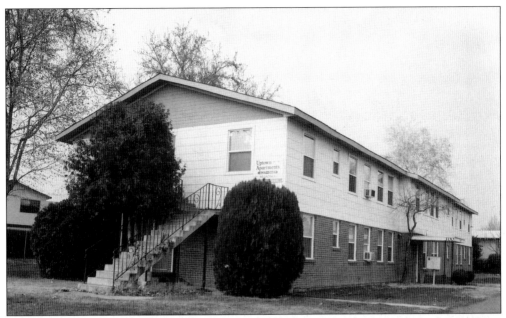

Between 1943 and 1945, the army built both men's and women's dorms in Richland. There were 8 dormitories for men and 17 for women. The buildings were originally located west of Jadwin, between Lee and Williams. This building, originally a men's dorm, was moved to its present location, on the north side of Van Giesen about halfway between Jadwin and George Washington Way. It is now an apartment complex.

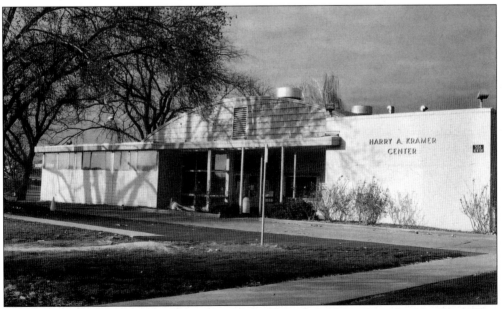

The Harry A. Kramer Center is one of the few buildings from the war era that is still standing. When first built, the center housed a Ford dealership. It was remodeled and on April 29, 1951, became the public library. The library moved to a larger facility in 1970. In 1977, senior citizens' activities were moved from the Community Center to this building. In 2001, the seniors vacated the old building, now slated for demolition.

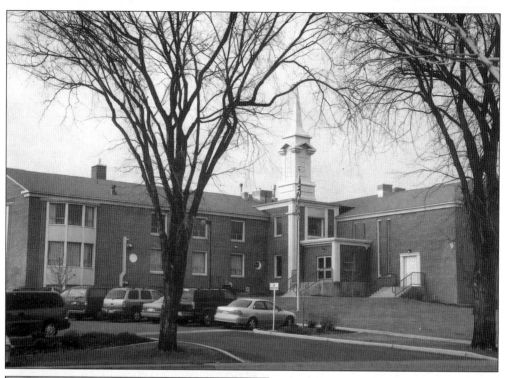

Most of the buildings in Richland are rather ordinary. But the first Mormon Church, located on Jadwin Avenue, has a more stately appearance. Groundbreaking for the church was on February 5, 1949. The new structure was completed in September of 1951 and dedicated on September 9, representing First and Second Ward. Ther president of the church was Woodrow G. Murray. The exterior of the building looks much the same as it did when built. Today the church also houses the Family History Center.

One of Richland's more unusual buildings, the Lutheran Church occupies the southeast corner of the Stevens and Van Giesen intersection, site of the former grange hall. Sometimes referred to as the "cupcake" church by locals, this church opened in 1951. Other buildings for Sunday school and church offices were added later.

Carmichael Junior High School opened its doors on February 28, 1949. The principal was C.I. Anderson. Originally the school was to be named for John Gray, an early settler. But when the school was about to open, former superintendent of Richland schools, S.P. Carmichael, was gravely ill. The name was changed to honor Carmichael. The school stands in its original location on the corner of Lee and Thayer. The school has gone through many renovations since it was first built.

One of the more recent developments on Columbia Point is this new marina. Many Richland residents dock their boats here for safe storage. There is also a sizable boat launch nearby for those who store their own boats. The newest addition is the *Columbia Voyager*, a new sightseeing excursion vessel. The inaugural launch was in April 2002. Throughout the summer and fall, daily cruises will navigate the Columbia River. The boat can also be reserved for conferences and weddings.

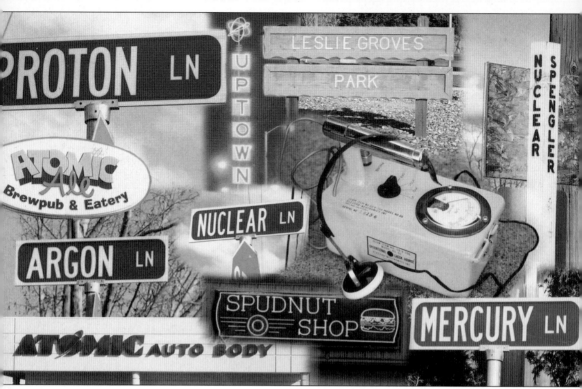

These are symbols of Richland's past, present, and future.